BETTER HOMES
— OF —
SOUTH BEND

AN AMERICAN STORY OF COURAGE

GABRIELLE ROBINSON

Published by The History Press
Charleston, SC 29403
www.historypress.net

Copyright © 2015 by Gabrielle Robinson
All rights reserved

First published 2015

Manufactured in the United States

ISBN 978.1.46711.865.1

Library of Congress Control Number: 2015943174

Notice: The information in this book is true and complete to the best of our knowledge. It is offered without guarantee on the part of the author or The History Press. The author and The History Press disclaim all liability in connection with the use of this book.

All rights reserved. No part of this book may be reproduced or transmitted in any form whatsoever without prior written permission from the publisher except in the case of brief quotations embodied in critical articles and reviews.

Dedicated to the courage, perseverance and intelligent cooperation of Better Homes of South Bend, creator of a thriving community

Contents

Acknowledgements 7

1. A Secret Meeting 11
2. The Officers 19
3. Separate Worlds 27
4. Stronger Than Legislation: Jim Crow in South Bend 43
5. Homes in a White Neighborhood 55
6. This Land Is Our Land 65
7. Impasse 71
8. Home 83
9. The Elmer Street Community 93
10. Yesterday's Lesson, Today's Challenges 105

Notes 133
Selected Bibliography 137
Index 141
About the Author 144

Acknowledgements

The story of how Better Homes fared in a harsh environment of discrimination and exclusion is brought to life through the recollections of contemporaries and their children, as well as through pictures, archives and the detailed minutes the group kept of its every meeting. I am grateful to retired teacher and social activist Linda Wolfson for having introduced me to Leroy Cobb, the last surviving active member of the group. Throughout, I rely on his vivid and sharp memory of the Better Homes years, which were transformative for the young man and had a lasting impact on his life. Leroy Cobb also provided a copy of the Better Homes minutes, dug up pictures and arranged meetings with the next generation. He never tired of answering my many questions about Better Homes, its members and South Bend in the 1950s. But his influence went even further. I always looked forward to our conversations for his insights and his invariably positive, life-affirming attitude. His intelligent and tolerant assessments of every situation taught me something beyond the scope of this book.

Nola Allen, a lawyer and professor, provided a perspective not otherwise available. She is the daughter of Lureatha Allen, who was to become president of the organization. Through her, I found out about the help Attorney Nathan Levy provided. She also gave me much-needed information on her parents and the defense housing in which they lived, sent pictures and was an always helpful and friendly presence on the phone.

For fleshing out South Bend's African American history, I was fortunate to have found as a guide John Charles Bryant, who made his vast knowledge

Acknowledgements

and network available to me. He helped with important connections, such as finding Nola Allen. He took me on extended trips through African American neighborhoods. I turned to him whenever I had a question about a person, an event, a building or anything to do with South Bend's African American history. Bryant has a wealth of historical stories, and I only regret that I could not incorporate all of them. He is a descendant of the influential Powells, one of the first African American families to come to South Bend. His friendship is one of the benefits of writing this book.

Many other leading African Americans of South Bend contributed their personal experiences and perspectives. Dr. Vagner was a lively source of the history of the times, in particular his own problems with purchasing a house. Even though the book is done, I look forward to many more conversations with him. Gladys Muhammad, director of the Colfax Campus of the South Bend Heritage Foundation, helped me with stories about growing up in LaSalle Park and her father's work at Studebaker. She also provided a folder full of documents about her fight—forty years after Better Homes—to induce banks to give loans to poorer African Americans. Thomas Broden, professor emeritus at the University of Notre Dame, filled me in on his years of struggle for fair housing in South Bend. Charlotte Pfeifer, Second District councilwoman for twelve years, provided insights into both the history of that area and its current needs. Regina Williams Preston shared with me the minutes of the Far Northwest Neighborhood Association and her own document "Yesterday's Lessons—Today's Challenges," which provides a close-up view of what is happening in South Bend's African American neighborhoods. Gail Brodie, president of the LaSalle Park Neighborhood Association, updated me on conditions in her area. Thelma Williams; the late Amanda Carothers, who was the first president of the Far Northwest Neighborhood Association; and Marguerite Taylor all helped me get a clearer picture. Dr. Irving Allen, son of Attorney J. Chester Allen, has given me information about his parents, who both were actively engaged in fighting for social justice.

A very special thank-you is due to the "children" of the Better Homes generation. They have provided stories about growing up on North Elmer Street as well as personal photographs. Every one of them has contributed to this story, but I want to thank in particular two of Leroy Cobb's daughters, Vicki Belcher and Beverly Reynolds; Brenda Wright; Keith Bingham; Kathy Bingham; Michael Jackson; Frank Anderson; and Rosie Warfield, who passed away in 2015. They all went out of their way to help me with information.

Acknowledgements

Then there were all the wonderful people at local archives who provided so much information and tracked down materials. The Local & Family History department of the St. Joseph County Public Library was an invaluable resource. I am particularly grateful to its manager, Joseph Siposz, and to library assistant Greta Fisher. They helped with information on housing and the history of LaSalle Park, and they provided pictures and maps. I still feel apologetic for taking so very much of their time. Alison Stankrauff, archivist, Franklin D. Schurz Library, Indiana University South Bend, prepared boxes of materials for my inspection and helped me track down images. Kristen Madden, archivist at the History Museum, also found important records for my work. Elicia Feasel at Historic Preservation took much care in copying deeds for the North Elmer Street homes. Andrew Beckman, archivist at the Studebaker National Museum, went out of his way to track down specific images of the foundry. George Garner of the Studebaker Museum and the Civil Rights Heritage Center shared his insights from his experience as archivist and event planner. All of them not only helped out a lot but also did so cheerfully, despite pressure on their own schedules.

Officers of the city of South Bend educated me on what was going on in the city during the time period. I am particularly grateful to Stephen Luecke, mayor of South Bend for sixteen years, for taking the time to talk to me about the problems of city revitalization. Gary Gilot, the former director of Public Works, helped me to understand the delays Better Homes encountered in its dealings with the city. Cherri Peate, director of Community Outreach, provided information on current conditions.

Photographer Peter Ringenberg spent much time with me to do a tour of South Bend, where he took all the photographs of current South Bend sites as well as the author photograph. His enthusiasm and expertise made it all fun. Another photographer, Kay Westhues, alerted me to the Via Crucis procession on LaSalle Park hill, and I include her striking image. When it came to reproducing images, Gene's Camera Store was my resource. All of them there, but especially Laura Sales, were indefatigable in helping me out. Special thanks go also to Michael Ivancsics, whose expertise rescued images I could not otherwise have used.

As always, my husband, Mike Keen, is my best critic, reader and listener. He spots problems immediately and doesn't let me get away with anything. Thanks to his eagle eye for flaws, several chapters were completely reorganized. And he took the time to do all this when he himself was swamped with his work at the Center for a Sustainable Future. I am so very grateful for his partnership and unvarying support of all my ventures.

Acknowledgements

I am sure I left out others who helped me with insights and information. All mistakes, however, are my very own. Thanks to their combined help, I hope to have drawn an engaging and accurate picture of the Better Homes initiative in the context of the 1950s and shown how its actions affected the next generation. The account is intended to give an intimate glimpse into a part of history that all too often is forgotten, both locally and nationally.

1
A SECRET MEETING

No information is to be given out.
—*J. Chester Allen, 1950*

After much thought and prayer, they finally garnered the courage to translate their dream into action. They had prepared themselves carefully and consulted widely. They also sought the advice of their ministers since they were all devout churchgoers, belonging to South Bend's many African American churches. This lengthy process allowed everyone's opinion to be heard and all fears to be aired. Only then were they ready to make their move, but in secret.

There had been whispers and private conversations that people were talking about forming a corporation to build homes. According to Nola Allen, it was her mother, Lureatha Allen, who started the ball rolling. Lureatha's parents had always owned their own home, and it was their daughter's ambition from a young age to do likewise. At last, here among friends and neighbors, she had found a group of like-minded people.

So it was on a Sunday afternoon, May 21, 1950, that a group came together to work on making their dream become reality. Their first minutes begin with this simple statement, formulated in the passive voice, which hides the power, hope and courage that underlies it: "A non-profit organization was formed and given the name 'Better Homes of South Bend, Inc.'" It was the first African American building cooperative in South Bend trying to break through the wall of segregation and defy the discrimination that relegated them to the poorest, most dilapidated parts of the city.

Better Homes of South Bend

> *May 21, 1950*
>
> A non-profit organization was formed and given the name, "Better Homes of South Bend, Inc."
>
> Officers were elected as follows:
> President — Mrs. Lureatha Allen
> Vice-pres. — Mr. Earl Thompson
> Secretary — Mrs. Louise Taylor
> Asst. Secy. — Mrs. Ruby Paige
> Treasurer — Mr. Bland Jackson
>
> Temporary Board of Directors:
> Clint Taylor
> Marcus Cecil
> Samuel Austin
> Thilma Paskill
> Beautha Fuller
>
> A contract was read by Lawyer Chester Allen, our legal advisor, and a likely prospect was mentioned by him as a beautiful site for building.
>
> Suggestions by Lawyer Allen:
> @ Money for secretarial record book.

This is the simple yet powerful opening sentence of the Better Homes minutes. *Courtesy of Leroy Cobb.*

An American Story of Courage

The Better Homes title sums up the group's endeavor. Its members desired nothing more than to own their own homes "in a nice neighborhood," as one of them characterized it. The name echoes the popular book *Better Homes at Lower Cost* and the *Better Homes and Gardens* magazine. Also, in the 1920s, a Better Homes of America movement grew to be famous across the nation. And in November 1944, an Institute of Better Homes of America came to South Bend to instruct the public on all aspects of home ownership.[1] Even though our group may not have consciously borrowed its name from any of these, the common designation attests to the enduring American dream that cuts across race and class of owning your own home.

At its first meeting, the newly minted group elected a full slate of officers: Lureatha Allen became president and Earl Thompson vice-president. The secretary was Louise Taylor with Ruby Paige as assistant secretary. And the treasurer was Bland Jackson. All the men worked at the Studebaker factory, and four out of the five officers were next-door neighbors on Prairie Avenue

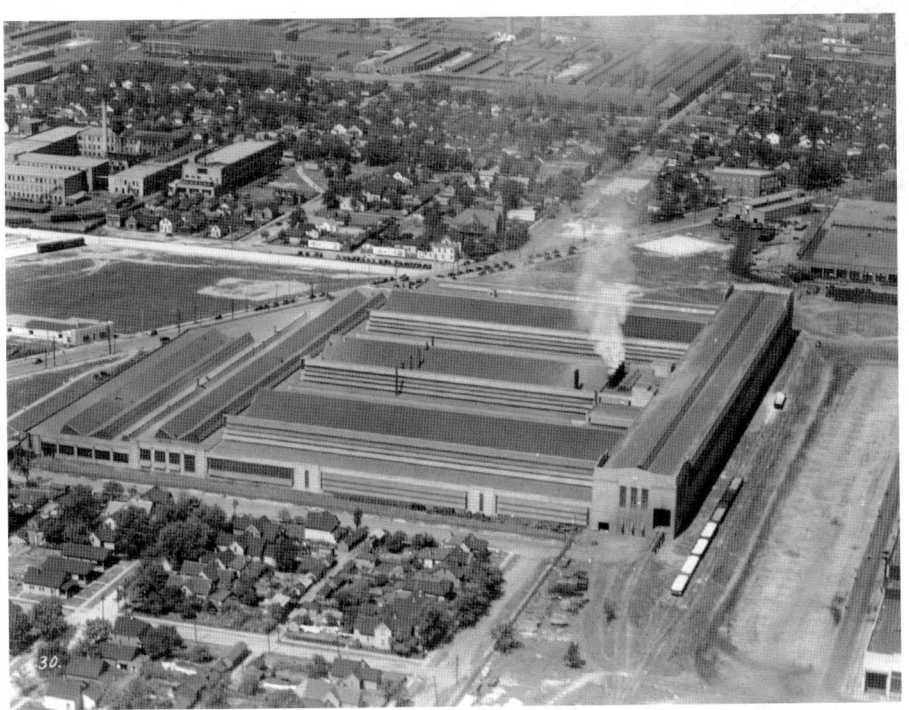

An aerial image shows the 1927 Studebaker foundry complex with the diagonal Prairie Avenue, where the Better Homes workers lived. *Studebaker National Museum Archives.*

across from the factory. The fifth lived less than two blocks away at the south end of the plant.

One other major actor was present at this first and all future meetings: the group's attorney, J. Chester Allen. He told them that he already had located "a likely prospect, a beautiful site for building." But nothing was said about its location. Allen wanted them to move quickly and secure the site before anyone was alerted to African Americans moving into a hitherto white neighborhood. He stressed the importance of acting as a corporation, which would give them a better chance at success than if they were just a group of individual families. To do this, they needed to prepare the necessary papers to file with the state. Once it received its charter, the corporation would purchase the lots and procure the loans. Only after all that was settled would the individual homeowners pursue their own mortgages. He told them that as a corporation, members needed to keep careful records of their activities and expenses and draw up bylaws as soon as possible. And they needed at least $2,000 basic capital for securing land options. Throughout the meeting, Allen emphasized that all their discussions and negotiations had to be kept secret. He insisted repeatedly that "no information is to be given out."

Allen did not have to spell out the reasons for this secrecy. Everyone in the room was all too aware of the precariousness of the situation. The people present had plenty of experience with discrimination in all aspects of their lives, at work, in housing, in their leisure activities. While discrimination in the North was not legalized as in the South, it still was publically sanctioned and ubiquitous. As Hartie Blake, a Studebaker worker from Mississippi, put it: "I left the South to get away from Jim Crow, and then I met Jim Crow in the North."

Everyone in the group had southern roots. Either they themselves or their parents had come from the South in search of a better life. Yet they had not found the equal treatment in the North for which they had hoped. Many factories in South Bend did not hire African Americans. Studebaker was the biggest employer, and even there, most African Americans were relegated to

Opposite, top: The hot and heavy work in the foundry is described in the Studebaker archives: "Dipping of Champion Six cylinder water jacket core assembly." *Studebaker Museum National Museum Archives.*

Opposite, bottom: Another scene from the Studebaker foundry. The description reads: "V8 cylinder head core making showing blowers and accessory equipment." *Studebaker National Museum Archives.*

An American Story of Courage

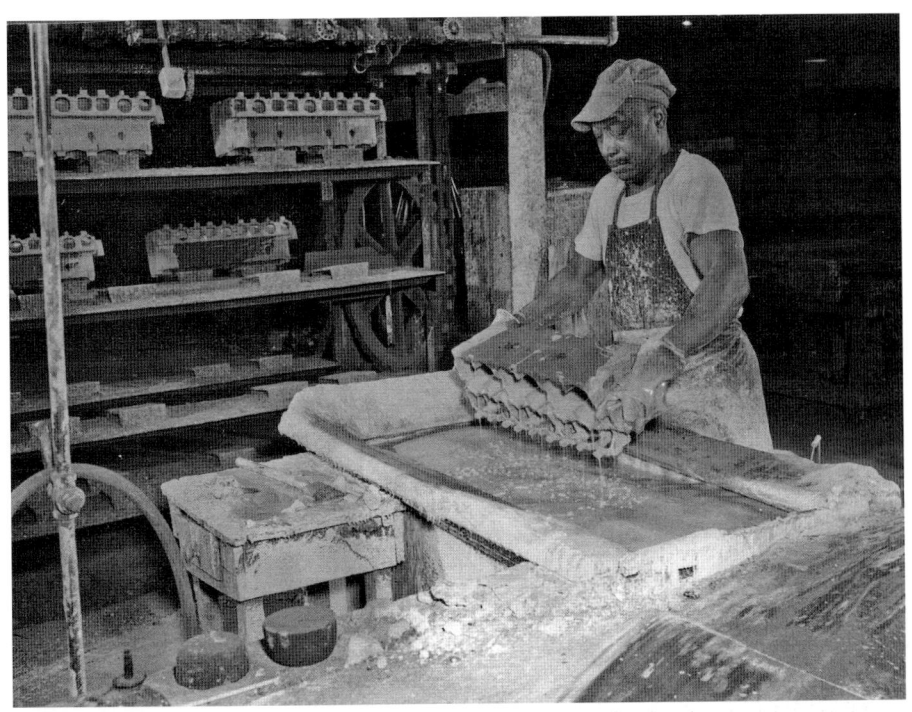

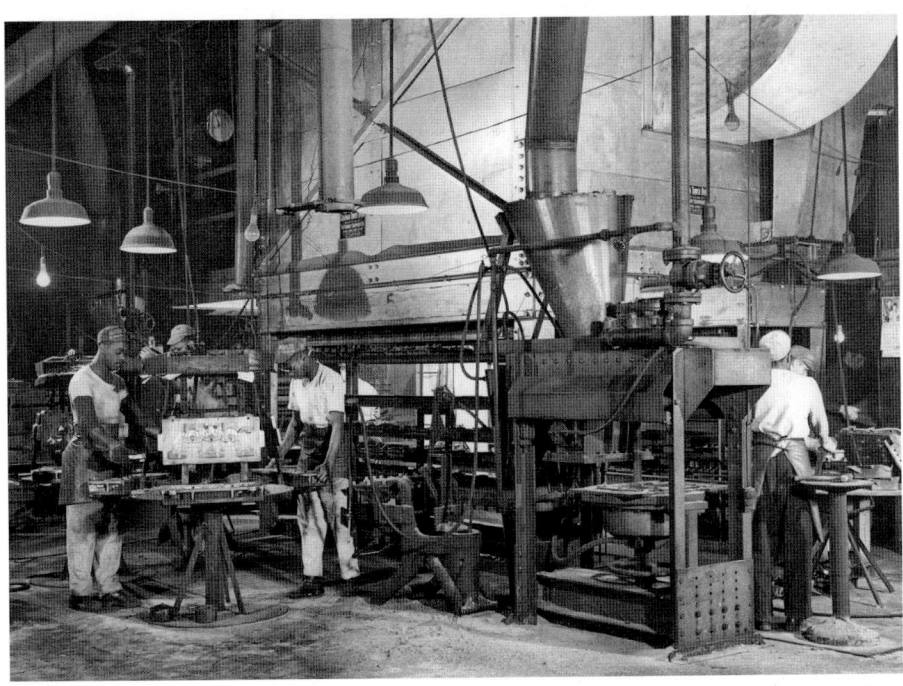

Better Homes of South Bend

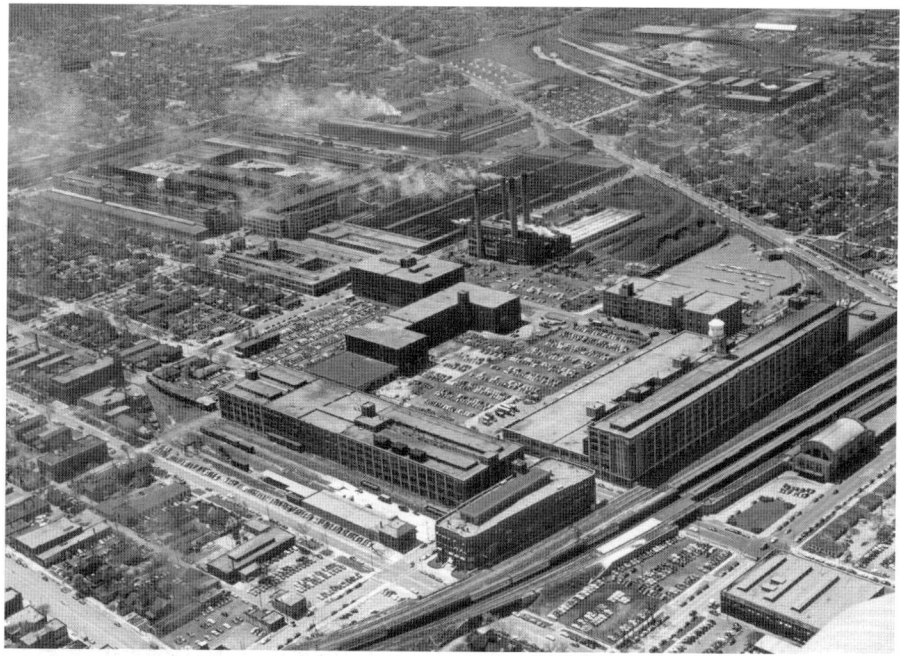

This Studebaker factory aerial shows the body plant in the foreground, the foundry complex in the back and Prairie Avenue diagonally on right. *Studebaker National Museum Archives.*

the foundry. It required lifting heavy loads, often in furnace-like heat. Beyond the workplace, they had to live segregated from the white population, often in slums wedged between factories. If they were lucky to have found a home to rent, these were for the most part temporary prefabricated structures, "defense homes," meant to be torn down after the war. They also were not welcomed—or sometimes even allowed entrance—in many of the city's public spaces, such as the high-ceilinged Philadelphia ice cream parlor and the tearoom at Robertson's department store. Many of South Bend's hotels and restaurants were closed to them.

At the end of the meeting, Allen asked each person to pay at least $1.00 to be placed in the treasury for miscellaneous expenses and that at every meeting, further donations should be collected. He suggested that Sunday continue to be their regular meeting day. After payment for postcards to inform people of meetings and $3.00 for rental of Hering House, the sum of $9.55 was placed in the treasury. Hering House was an African American community building located on Western Avenue. It was just north of Prairie Avenue, where most members lived.

An American Story of Courage

The popular and fancy Philadelphia Ice Cream Parlor in downtown South Bend, 1942. Only white guests were allowed. *History Museum of South Bend.*

During the more than three years it took to pursue its dream, Better Homes demonstrated ingenuity, intelligence and perseverance as the group faced the local power structure and its pervasive racism. Throughout that time, its members worked together in a democratic and cooperative manner, reaching out to all constituencies. In this, they set an example of what W.E.B. Du Bois, one of the founding fathers of American sociology and author of *The Souls of Black Folk*, had envisioned in 1933 for just such a group of industrial workers. He called for African Americans to work together in "intelligent cooperation," saying, "It is now our business to give the world an example of intelligent cooperation so that when the new industrial commonwealth comes we can go into it as an experienced people and not again be left on the outside as mere beggars."[2]

This, then, is a story of American courage. Although racism was rampant at that time, the Better Homes group cannot be seen merely as passive victims of white oppression, which, robbing them of their own agency,

would doubly victimize them. On the contrary, their struggle shows them to have been the true defenders of American values: freedom, democracy and engaged citizenship.

2
The Officers

We were just like family.
—*Leroy Cobb, 2014*

Lureatha Allen seemed a natural choice for president. She was a born leader, able to speak well, and she commanded authority. She knew how to make the right connections with people who could help them, such as Attorney Allen. Lureatha was born in Oklahoma on May 23, 1911, but her family soon moved north. She grew up in Grand Rapids, Michigan.

Lureatha was married to Arnold Allen, who was born in 1907 near Memphis, Tennessee. His family moved to Detroit when he was two years old. He was a musician who had his own band up until World War II. Then, one by one, the young men of his band were drafted. At age thirty-seven, he himself was drafted into the navy as an entertainer. A family picture shows Lureatha Allen as a poised, attractive and fair-skinned woman. Her daughter said that when her mother was hospitalized with a stroke, the admission records listed her as white. Arnold is a slender and good-looking young man, several shades darker than his wife.

While her husband was away, Lureatha Allen worked at Studebaker to support her ten-year-old daughter, Nola. She showed her leadership capabilities already at the factory, where she was active in the Congress of Industrial Organizations (CIO), which included the United Auto Workers (UAW). The UAW Local 5 was established in South Bend in 1933. The CIO was more progressive than its rival and former partner, the craft-oriented American Federation of Labor (AFL), which did not accept African American members.

BETTER HOMES OF SOUTH BEND

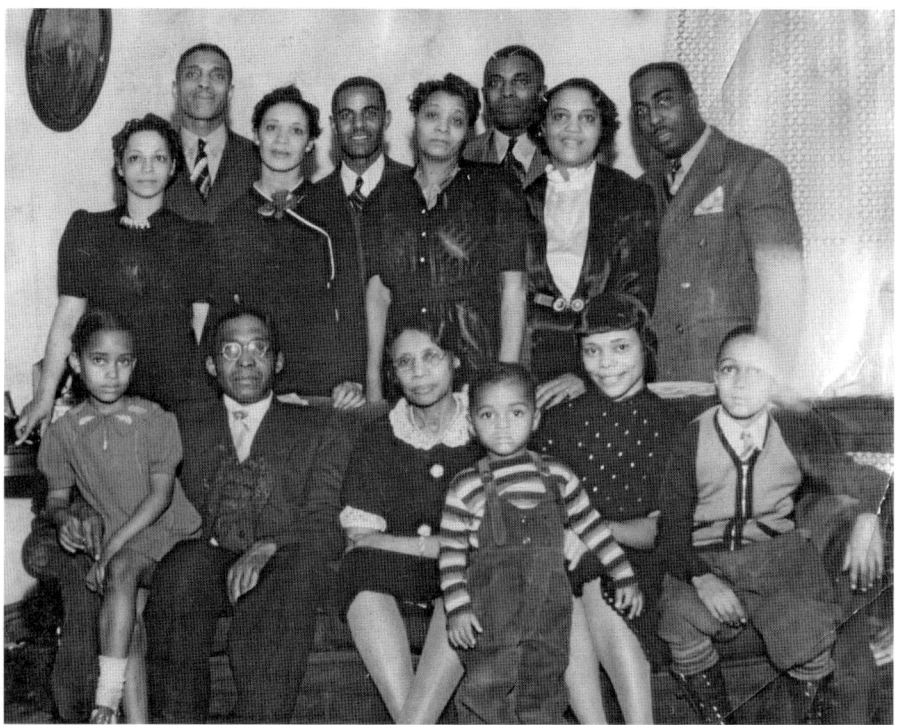

A picture of Lureatha Allen's family circa 1940 shows Lureatha and Arnold standing third and fourth, respectively, from left. *Courtesy of Nola Allen.*

When Arnold Allen returned to South Bend after the war, he got a job at Studebaker. He was a metal finisher in the pressroom, where he sanded and painted fenders and other auto parts. Nola still remembers vividly her family's joy when his wages rose to one dollar per hour. With the help of the GI Bill, Arnold also learned to repair radios and televisions and created the Linden TV and Radio Repair shop. The money he made with this went for his hobbies, his boat and his car. He also took up music again, and the money from that went straight into Nola's college fund. Despite these extra sources of income, Nola remembers that they were still living from paycheck to paycheck.

After her husband's return in 1945, Lureatha left Studebaker, but she continued to work. In 1945 and 1946, she was a cafeteria helper. It was only in the years from 1947 to 1950, when Better Homes started, that she was without an outside job. But by 1951, she was a finisher at Crystal Cleaners and Laundry. Then she became a nurse's aide at the Indiana Children's Hospital for mentally disabled children in South Bend, a job she held until retirement.

An American Story of Courage

Lureatha Allen also was active in several of the leading organizations of her community. She served as stewardess in her church, Olivet AME Church, where her husband, for a time, was chair of the trustee board. In addition, she was a member of the Household of Ruth, the female order, founded in 1858, associated with the Grand United Order of Odd Fellows (GUOOF). Its rules were to "assist the men of GUOOF, relieve the needy, relieve the sick, and relieve the distressed." She also belonged to the Pierian Club, one of the oldest African American women's clubs, dating back to 1891. It dedicated itself to "mutual self-improvement through literary study and intellectual discourse at a time when higher education for women was not readily available."

The Allens lived in one of the prefabricated homes supplied by the federal government for workers in the defense industries. Their address was 1319 Prairie Avenue. There were several rows of these so-called defense homes in their block, duplexes situated in the space between two railroad tracks and directly across from Studebaker. They all had the same layout. The front door opened directly into the living room. Toward the kitchen wall at the left was a brown metal stove that heated the house, with ducts running along the ceiling. Nola did her homework at a little desk by the window that also held the telephone. This setup had the advantage that she could call her friends when she got stuck on a math problem, and they could work on it together over the phone. The house had hot water, which was heated by a coal-fired stove in the kitchen. When hot water was wanted for a bath or the dishes, someone had to make a fire in this small stove. A narrow hallway led from the living room to a linen closet, the bathroom and two bedrooms at the end. The floors were covered with linoleum throughout.[3]

Like the Allens, vice-president Earl Thompson lived in a defense home at 1339 Prairie Avenue. He was from Newton, Alabama, where he was born on July 4, 1915. His family had come to South Bend when Earl was five to join relatives already there. Earl Thompson worked in the machine shop at Studebaker. He was active in his church, St. John Missionary Baptist Church, serving in many capacities. He was a deacon, as well as on the deacon board; a senior choir director; and a part-time church custodian. He also was a member of the Urban League. In a picture taken on his thirty-sixth birthday in 1951, Earl looks elegant and debonair in a double-breasted suit with a hat tilted on his head, one leg thrown forward leisurely and a big smile. He was something of a lady's man and three times married. At the time Better Homes got started, he was with his second wife, Viro, who also had come

Better Homes of South Bend

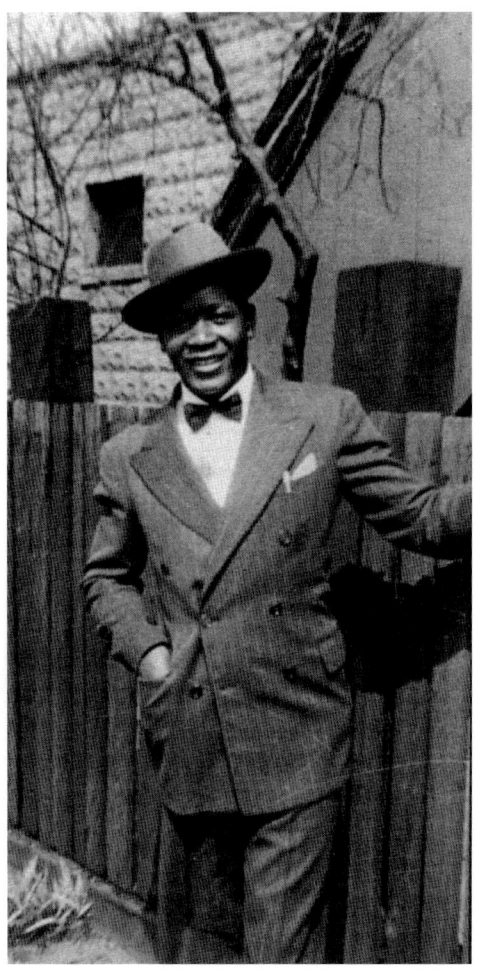

Earl Thompson looks happy and debonair on his thirty-sixth birthday in 1951. *Courtesy of Leroy Cobb.*

from the South at a young age. They had three children, Earl Jr., Gloria and Patricia.

Secretary Louise and her husband, Robert Taylor, both had arrived in South Bend in the early 1940s, and Robert Taylor got a job as a laborer at Studebaker. They lived at 1313 Prairie Avenue. The couple had no children, and Louise did not have a job outside the house. All that is available about Louise is the sad and lonely end to her life. She died alone in her apartment at 823 Portage Avenue on June 28, 1966, but her body was not discovered until days later.

Assistant Secretary Ruby Paige, wife of Sherman Paige, lived at 1517 South Catalpa Avenue, just east of Prairie Avenue on the south side of the Studebaker factory. In 1950, Ruby worked as an aide in St. Joseph Hospital and later at the Urban League and Riess' furniture store. Throughout her life, Ruby Paige was active in community affairs. She served in the Urban League, where both she and her husband were patrons. Asked whether she had received equal treatment in local retail stores, Ruby Paige responded: "Not early on, no…blacks were not treated equal. They [sales personnel] would walk all over us, act like we weren't there, and then wait on a white customer."[4] In 2015, Ruby Paige, well into her nineties, is one of the three surviving members of the original Better Homes group, but she is in a home suffering from dementia. Ruby's husband, Sherman Paige, was born in Indianola, Mississippi, in 1919, and his family came to South Bend in 1922. He

joined the armed forces in 1943 and married Ruby the same year. He was an assembler at Studebaker.

Treasurer Bland Jackson was born on September 1, 1919, in Sunflower, Mississippi, just a few miles north of Sherman Paige's hometown, Indianola. He served as a sergeant during World War II and, after the war, joined his wife in South Bend, where she had moved to be with relatives in his absence. Like Earl Thompson, he worked in the machine shop at Studebaker. His wife, Rosa, stayed home to look after their children: Gregory Donald, Michael Ray and Blandette Rose. The Jacksons lived at 1311 Prairie Avenue and, like the Thompsons, were members of St. John MB Church.

Even these thumbnail sketches of the Better Homes officers show that they were engaged citizens, actively involved in their churches, the Urban League, clubs and other civic organizations. Two other features make them stand out from the rest of the Better Homes members. None of the men in this leadership group worked in the foundry. Instead, they had better jobs on the assembly lines, the machine shop and the pressroom, which were as "different from the foundry as night and day." In addition, Lureatha; her husband, Arnold; Earl Thompson; and Ruby's husband, Sherman, all grew up in the North. It was their parents who had come from the South to make a better life for their children.

In most other characteristics, the entire Better Homes group followed the typical pattern of the migrants from the South. Contrary to popular myth, which saw these migrants as being ignorant and illiterate, "the migration of blacks out of the South has clearly been selective of the best educated."[5] They had fewer children than the families they left in the South and the European immigrant families in the North and raised their children in two-person families. They worked hard so that despite their rough start, they ended up being better off than their peers.

Better Homes attorney J. Chester Allen was a man with a long list of "firsts" to his credit. He was the first black man on the South Bend City Council, as well as on the school board; the first black president of the St. Joseph County Bar Association; and the first African American state senator from South Bend, elected in 1938. There were only two other African American state senators there at the time, both southerners: Henry J. Richardson from Alabama and Dr. Stanton from Arkansas.

J. Chester Allen was born on December 25, 1900, in Pawtucket, Rhode Island, when the town had just under forty thousand inhabitants and most of them worked in the textile mills. Shortly before his birth, his family had come north from Charleston, South Carolina. His father, Joseph Chester

Allen, was a school custodian and his mother a homemaker. Allen, who showed his intellectual prowess early in life, attended Brown University, from where he graduated in 1923. From there, he went to the Boston University School of Law, finishing his degree in 1929.

From the moment he arrived in South Bend to start his law practice, Allen used any means he could in his struggle for racial justice. He worked through the agencies of the Urban League and the local chapter of the NAACP. He aligned himself with progressive whites. He wrote letters and publicized the wrongs he saw. Despite untold setbacks, he never gave up. One good example of his dedication and perseverance is his nineteen-year-long fight to get South Bend's indoor swimming pool opened to African Americans. One of his first actions in South Bend, fresh from law school, was to file a complaint against discrimination and exclusion at the Engman Public Natatorium. Built in 1921–22, the natatorium was a fine structure on West Washington Street, not far from the Studebaker and Oliver mansions, the largest indoor pool in Indiana. Allen's original complaint was denied, but he kept fighting for his cause. In 1937, the natatorium was opened to African Americans but only on restricted days. And the saying went that after their visit, the water was drained and the pool made ready for the white population the following day. It took nineteen years, but in the end and in collaboration with others, Allen succeeded. On February 3, 1950, the Board of Parks declared the pool open to all. Despite this, however, African Americans still were not welcome there. Even the children realized this. Rather than suffer the nasty stares of white kids, the boys preferred the gravel pit on Bendix Road.

Allen had met his wife at law school, and they got married in 1929. According to their son Dr. Irving Allen, his parents actually eloped, although he does not know exactly why.[6] Elizabeth Fletcher was born in 1905 in Chicago. Both her parents were college graduates. Her father, Joseph Fletcher, was a builder for the American Missionary Association. One of his jobs was to build the library at his alma mater, Talladega College, Alabama's oldest private black liberal arts college. Its proud history goes back to 1865 with the motto "We regard the education of our children and youths as vital to the preservation of our liberties and true religion as the foundation of a real virtue." Joseph Fletcher's work is commemorated in one of the college's famous Hale Woodruff murals in which he is depicted overseeing the construction of the library. Elizabeth also went to Talladega College and graduated in 1926. The college prides itself on instilling "in its graduates the values of intellectual excellence, hard work, and morality."[7] It must have been the perfect place for the young woman, who achieved intellectual excellence

AN AMERICAN STORY OF COURAGE

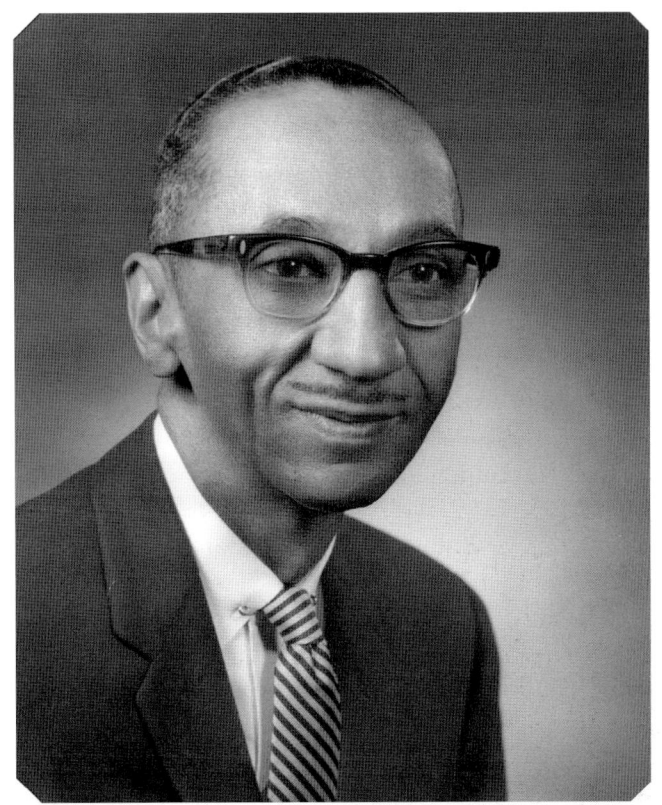

Right: This portrait of Attorney J. Chester Allen was taken at about the time he worked with Better Homes. *History Museum of South Bend.*

Below: This 2015 front view of the Engman Natatorium shows the building much as it was when it was erected in 1922. It now houses the Civil Rights Heritage Center of Indiana University South Bend. *Peter Ringenberg, photographer.*

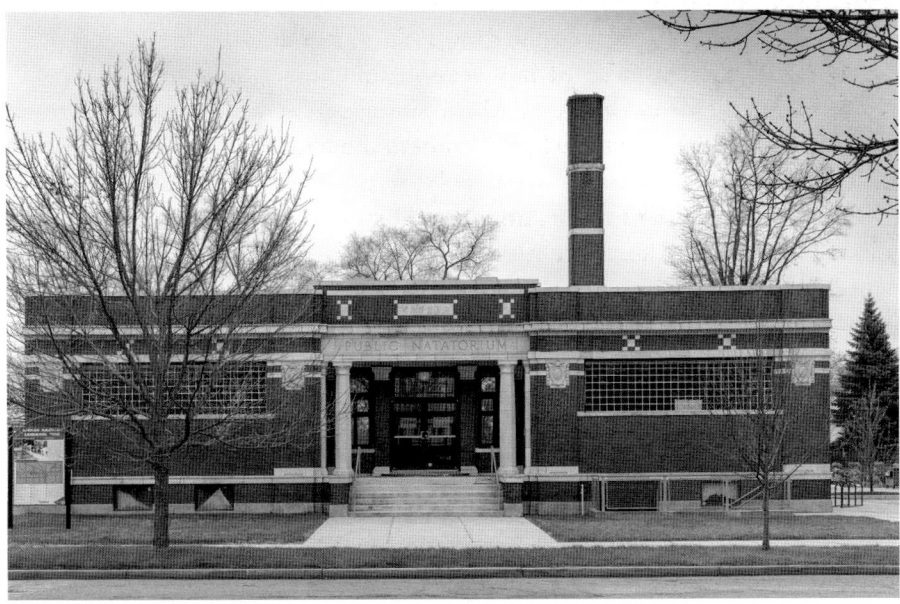

and dedicated her life to fighting for African American and women's equality. Her experience there was so valuable that Elizabeth did all she could to help South Bend high school students attend Talladega College as well.

At law school, Elizabeth lost a couple years because of tuberculosis, so she graduated several years after her husband and joined him in South Bend in 1933. She was one of the first female African American lawyers in Indiana, and together they founded the law firm Allen and Allen in 1939, thereby becoming the first husband-and-wife legal team in the area. For three decades, their offices occupied rooms 416–418 in the Lafayette Building at 115 South Lafayette Boulevard, across from the Saint Joseph County Courthouse. The five-story brick building with an ornamental stucco front, a little down at heels at present, is still there today. According to her son Dr. Irving Allen, it was Elizabeth Allen who articulated the argument about taxes paid by African Americans that became crucial in opening the Engman Natatorium to them.

The Allens lived at 501 East Howard at the edge of the Notre Dame neighborhood mainly populated by white families, although a few blacks, such as the Cross family, could be found in the same block. Their two-story white clapboard house on a hill still stands. It was a Sears house put together on the premises, and the family added a pretty verandah at the back. Their sons, J. Chester Jr., born 1933, and Irving, born 1939, both became successful professionals. The eldest continued in his father's footsteps, working in his family's law practice and later becoming the first black judge in South Bend. The younger son, Irving M. Allen, became a physician. Tragically, their only daughter, Sarah, died in 1962, when she was only twenty-six years old. She, too, had wanted to be a lawyer.

This was the core of the Better Homes group, but soon others would join them. They were united in their mission to break out of the segregated confinement where they were forced to live. They wanted to find homes away from the factories and slums that surrounded them and give their children a better start in life than they themselves had. That was the reason their families had moved north in the first place. This close-knit group of neighbors and friends ranged in age from seventy to just twenty. "We were just like family," remembers Leroy Cobb, by far the youngest in the group at age twenty.

3

Separate Worlds

There are people who think that the Negro is in the same environment that the white man is, since they are living side by side in a city. They are not.
—*Buford Gordon, 1922*

Up into the 1930s, black and white working-class families lived next to one another peaceably near the factories on the western side of South Bend. They were all newcomers. African Americans had just arrived from the South, and their neighbors, for the most part, were recent Eastern European immigrants, new not merely to South Bend but to the United States and its language and customs. Moreover, African Americans remained vastly outnumbered. In 1920, according to the Reverend Buford Gordon's study *The Negro in South Bend*, there were but 1,269 African Americans in South Bend out of a population of 70,983.[8] Although their numbers increased throughout the 1920s, still in 1930, South Bend had only 3,431 African Americans in a population of 104,193.[9]

Leroy Cobb, who joined Better Homes in June 1950, remembers that as he was growing up, there were but two black families—his own and the Lutons from Hickman, Kentucky—in an area of several square miles. They were all poor, and they got along. Leroy's parents were part of the first wave of the Great Migration from the South. The term refers to the millions of African Americans who moved from the South to the North between 1910 and 1970. They first came in large numbers when the United States got ready for World War I and its source of workers from Europe had dried up. The second wave occurred in preparation for World War II. At least 1.6

million southerners came north in this second wave, including the majority of the Better Homes group. They were the pioneers, the first industrial working-class African Americans. James Grossman notes in *Land of Hope*, "As the first generation of black Americans to secure a foothold in the northern industrial economy, the migrants represent a crucial transition in the history of Afro-Americans, American cities, and the American working class."[10] And South Bend, if not as desirable a destination as Chicago, still was attractive for its many industrial jobs.

Leroy's father, who was related to Earl Thompson, had come with his parents from Jackson, Tennessee, in the early 1920s. His mother had moved to South Bend from Newton, Alabama, in 1927, when she was eighteen years old. Leroy's parents rented a succession of apartments, all on the west side of South Bend in the vicinity of the city's major factories, while his father worked his way up to become an assembler at Studebaker. After a divorce, his mother and her new husband, together with Leroy, settled at 508 South Laurel Street, the last house right next to the New York Central railroad tracks. One block to the west was the Studebaker factory, and immediately to the east was South Bend's other industrial giant, the Oliver Chilled Plow manufacturing company.

Neither Leroy nor his parents encountered any difficulties with their white neighbors. He remembers playing with Johnny Polanski, the son of Polish immigrants who lived close to him on Laurel Street. His family felt safe, and on hot summer days, they slept on their porch, as did their neighbors. "We didn't lock our doors. I don't ever remember having a key to my home." This friendly coexistence was confirmed by Helen Pope, who also grew up on the west side next to Polish and Hungarian immigrants. The immigrants shared produce from their gardens and exchanged recipes. Her mother taught a Hungarian lady to prepare southern fried chicken, and that lady returned the favor with kolacs and kieflies. "The bond that we had was because we were all just coming here for the first time," Helen reminisced. "We respected each other and we learnt from each other's cultures."[11] Helen Pope became one of the first African American nurses in South Bend and an influential civil rights activist. As Social Services director at the YWCA, she initiated an educational program for young girls, essentially a Head Start program before Head Start was founded.

Leroy started out at Linden School, a mile from his home, and there, too, he got on well with the white students and the teachers, all of whom were white as well. The school had opened in 1890 to serve the Polish and Hungarian immigrant children of the neighborhood. By the end of the

An American Story of Courage

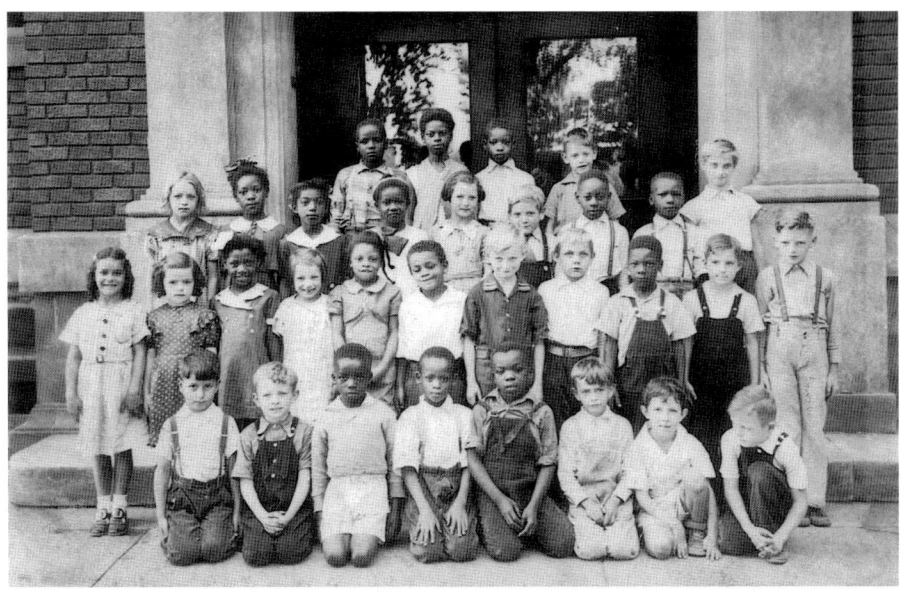

This Linden School class photograph of 1937 shows Leroy Cobb in the second row, third from right. *Courtesy of Leroy Cobb.*

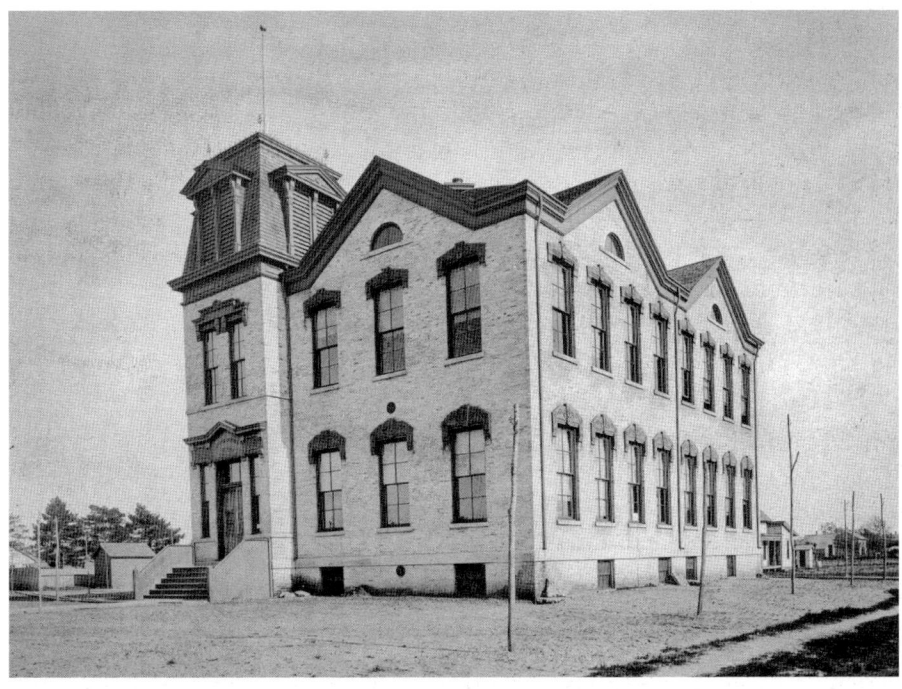

Here is the beautiful building of Linden School in the early 1900s when it was attended by only white students. *History Museum of South Bend.*

1950s, it had become entirely African American. Leroy's elementary school class at Linden School in 1937, when he was seven years old, had thirteen black boys and girls out of thirty-two children, and they were dispersed among the group. White and black kids alike had poverty in common. "If you had a pair of Sunday shoes and a pair of tennis shoes, you were lucky. When you got a hole in your Sunday shoes, you put cardboard in. If you had no tennis shoes, you had to do gym in your socks, and you made sure there were no holes in them."[12]

Even though in the 1920s and 1930s there was little friction and even some valuable interaction between the predominantly white population and the much smaller African American one, the two groups already lived in separate worlds. Yet most of the whites remained ignorant of, or actively ignored, this fact. This was one reason why Reverend Buford Gordon wrote his book *The Negro in South Bend: A Social Study*. In it, he said: "There are people who think that the Negro is in the same environment that the white man is, since they are living side by side in a city. They are not."[13]

Buford Gordon, born on August 24, 1893, in Pulaski, Tennessee, the birthplace of the Ku Klux Klan, had been trained both for the ministry and in sociology. He came to South Bend in 1920, to serve as the first minister of a chapel that was part of the Olivet AME Church. Gordon had just left the University of Chicago, where he had studied under professors Robert E. Park and Ernest W. Burgess, founders of the Chicago School in urban sociology who did extensive research in the city of Chicago. In his book Gordon followed the model of his professors in Chicago as well as W.E.B. Du Bois' 1899 account, *The Philadelphia Negro: A Social Study*. Gordon used his book to sound a strong warning against the growing racism he observed among whites. He saw that "public sentiment had been built up, which is stronger than legislation, against Negroes coming into certain localities."[14] Gordon understood that legislation alone is ineffective if it is not supported by public sentiment. His conclusion and advice to his fellow African Americans is the same one Du Bois advocated ten years later: "The great need is for the Negro to come together and combine his interests and his earnings and lift himself so high that the world will seek him."[15]

In 1924, Gordon experienced firsthand the "public sentiment" about which he had written and its racism. His chapel had just become an independent church, the First African Methodist Episcopal Zion Church. While the new church was under construction at 801 North Eddy Street in a white neighborhood, the Ku Klux Klan invaded its premises at night and damaged

the building. After that, Gordon and members of his church had to keep all-night vigils in order to prevent further damage.[16]

Gordon's research into working and living conditions for African Americans showed that in 1922, the Oliver Manufacturing Company employed no African Americans except for two female janitors. The company had become world famous for the invention of its patented chilled plows. Their hard and smooth surfaces made plowing much easier than the old wooden plows with only metal edges. The Bendix Company, brake pads manufacturer for cars and planes, also did not hire any African Americans in the 1920s. The Singer Sewing Machine Company, which built the wooden shells of its sewing machines in the South Bend plant, had only

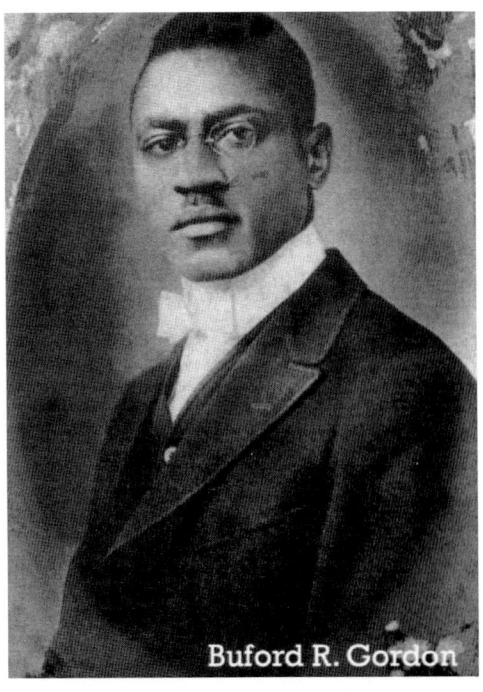

This picture of Buford Gordon appeared on an Indiana University South Bend invitation celebrating the republication of his book *The Negro in South Bend*. Courtesy of Leroy Cobb.

fifty-four. The Studebaker Company became by far the largest employer of African Americans in South Bend and remained so over the decades. Gordon mentioned that the company even had one black foreman.[17] During World War I, the factory employed seven hundred African Americans, although that number dropped to half immediately after the end of the war.[18]

Gordon also emphasized that South Bend had few places for African Americans to socialize and relax. The YMCA was closed to them, as were most downtown hotels and restaurants. Helen Pope had noticed that at Kresges, which was one of the few places where African Americans could go, up until the 1930s, they had to drink their root beer out of separate glasses that had the bottoms painted black.[19] Dr. B.W. Streets, an African American dentist, described what he had to go through if he wanted to watch a movie at the Colfax Theater in 1930: "The Colfax Theater did not allow blacks to sit down in the lower seats of the theater. Blacks had to buy their tickets and go out the door around to the back and up to the

buzzard's roost. The buzzard's roost was so high, and it was so small, it was hardly worth a person's time."[20] And even if hotels, restaurants, theaters and department stores did not explicitly exclude African Americans, black patrons did not feel welcome and so stayed away.

In response to such ubiquitous and humiliating discrimination and exclusion, the African American community created their own places for business, worship and entertainment. By 1958, a South Bend Urban League

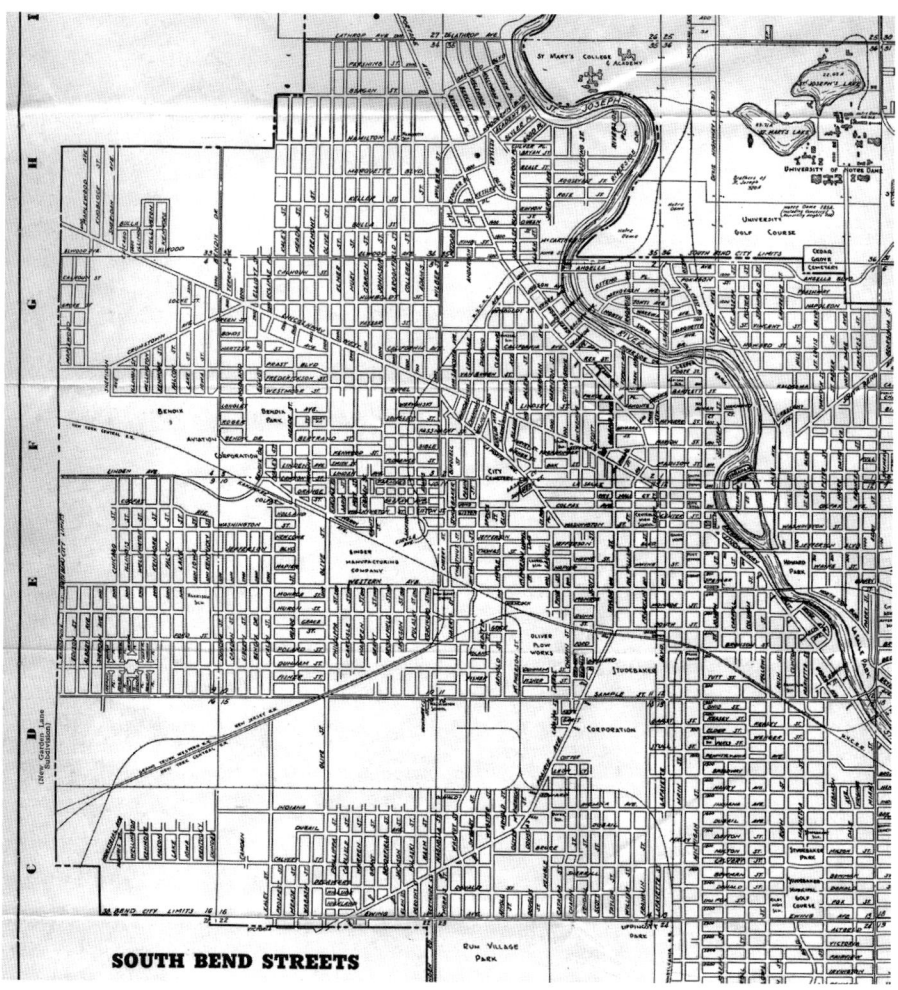

A map of South Bend, 1941. Studebaker is located to the southwest and Lincolnway West angles diagonally to the northwest. In the north, Elmer Street is just to the west of where the St. Joseph River makes a large loop. *Collection of Local & Family History Services, St. Joseph County Public Library.*

study identified eighty-one African American small businesses in the city, including hotels, restaurants, food markets, cleaners, liquor stores, pool rooms and doctors' offices. The largest district was located right next to the Studebaker and Oliver factories in the 400 and 500 block of South Chapin Street. The two blocks ran from the New York Central Railroad tracks north to Western Avenue. Across Western Avenue, there were no African American businesses on Chapin Street, except for Bob Harris' Tavern and a barbershop.

In the 400 block of Chapin was the famous Ma Hodges Hotel and Restaurant, the place where most African American visitors, speakers and performers stayed since they were not welcome in the downtown hotels. Next to it were Thern Parks Cleaning and Mrs. Sweeney's Restaurant. The Z.B. Falcons, serving a white audience, also could be found in the 400 block of Chapin. The 500 block, closest to Studebaker, featured a number of pool halls—Shelton's, Mitchel's and Smoke's Pool Hall and Tavern—as well as Newbill's Barber Shop.

The African American housing developments of Maggie's Court and Horse's Alley were just a block east on Western Avenue and Scott Street. The forty-four small houses, in which fifty-four families were crowded together, were located only two blocks north of Prairie Avenue, where the Better Homes officers and many of the members lived. There were two businesses on Scott Street: Woolridge's Funeral Home, until the 1940s, the only black funeral home in South Bend, and Mrs. Wolfe's grocery store. At the end of Horse's Alley on Scott Street was one of the most popular entertainment spots: the Trianon Dance Hall. It was right next to the New York Central tracks with Studebaker's factory on the other side. Popularly referred to as a "juke joint," the Trianon, situated above an apartment, was packed on weekends, especially when there was a live band. But people also crowded in when there were only jukeboxes for music. Leroy Cobb remembers that it was at the Trianon in the early 1940s where he saw slot machines for the first time.

On the corner of Chapin and Monroe Streets was the white-owned Fisher's grocery store, which had an almost exclusively black clientele since Maggie's Court and the defense homes were nearby. Across from Hering House on Western Avenue was South Bend's only African American drugstore, Perry's Drugs. Starting from the orthodox synagogue on William Street, east of Chapin, there also were a number of Jewish businesses in the area, many with living quarters for the owners above the stores. The best known was the Jewish-owned clothes store Rosenbaum's, located next to

Hering House. In contrast to the predominantly white clientele of downtown South Bend, this was a richly diverse neighborhood.

The other major African American business district was on Birdsell and Liston Streets, just north of the 1500 block of West Washington Street. It was what today we would consider a complete city neighborhood in which businesses, single homes and apartment buildings were mixed in with schools, churches and other public buildings. Businesses sprouted in the 1920s and 1930s around three churches that were located near one another in a sort of circle. Pilgrim MB Church was on the east side of Birdsell Street, half a block north of Washington Street. Less than a block west on North Adams Street was St. John MB Church, and south of it directly on West Washington Street was the Catholic St. Augustine's Church.

A favorite spot in that district was Uncle Bill's Big House on Birdsell Street, which served as both restaurant and meeting place for African American clubs and organizations. The owner had started African American softball and baseball teams that also met there. From Uncle Bill's south to Liston Street were a string of businesses, ending in the Liston Hotel across from Pilgrim Church. The only house still standing today is the former Higgins Funeral Home. Adjacent to Pilgrim Church were Harriet Sanders Ice Cream Parlor and Haynes Funeral Home. A block west was Wilder's Hotel, next to St. John Church. Immediately north of St. John were the grounds of Linden School. The South Shore Railroad commuting between Chicago and South Bend ran on Colfax Street, a block north of Washington Street. Also on Colfax was the Order of the Knights of Pythias, and the next block north on Linden Street had the Mason's, Burns' barbershop and the Cozy Theater. Farther north, the neighborhood became increasingly white, settled with Polish and Hungarian immigrants.

On Birdsell and Washington Streets, a few yards from Pilgrim Church, was another much frequented place. A two-story brick building housed Ford's barbershop and Hank's Pool Hall on the ground floor. Above those, the African American political leadership of South Bend met. They called themselves the Sanhedrin Club, after the supreme council of ancient Israel. Chester Allen was a member, as was Reverend Bernard White from St. John. Attorney Zilford Carter's offices were upstairs as well. Together with Chester Allen, he was instrumental in opening the natatorium to African Americans. The building also had a community food pantry.[21]

Church provided one of the main support networks for the African American community and especially for the newcomers from the South. The first African American church in South Bend was the Olivet African

An American Story of Courage

The original building of the first Olivet AME Church occupies the foreground. Behind it is the Studebaker body plant in 2015. *Peter Ringenberg, photographer.*

Methodist Episcopal Church, organized in 1873. It began at 310 West Monroe Street but later moved to the east side of South Bend at 719 Notre Dame Avenue. The smaller group of African Americans who live on the east side of the city still is predominantly associated with Methodists while the west side is largely Baptist. Among Better Homes members, only Lureatha and Arnold Allen, the Chambers and the Cokers belonged to Olivet Church, all the rest were members of Missionary Baptist churches.

Pilgrim Missionary Baptist Church, called Mt. Zion Baptist Church when it was established in 1890, is the oldest Baptist church in South Bend. For just one year, it was located at the corner of Main and Jefferson Streets in a wooden building donated by Studebaker. In 1891, the building was moved to its present location at 116 North Birdsell Street at the corner with Liston Street. In 1919, the local chapter of the NAACP was founded on its premises. That same year, the church started a new building on the site, but in the beginning, it could afford only a basement. In 1920, in "troubled, quarrelsome, and tumultuous times,"[22] the church fired its minister, and part of the congregation broke off. Mt. Zion was left with only six members. They then changed the church's name to Pilgrim Missionary Baptist Church. The Depression added financial troubles, but the church managed to survive. Gradually, the congregation grew once more.

BETTER HOMES OF SOUTH BEND

The splinter group from Mt. Zion joined another small congregation. Together, they organized a new church, St. John, on July 1, 1922, at the nearby Knights of Pythias Hall. By the early 1930s, St. John had collected enough money to start a church of its own, but at first, it, too, could build only a basement. It was located across from Pilgrim Church at 130 North Adams. When Reverend Bernard White became St. John minister in 1944, his popularity and preaching skills attracted many new members so that it could afford to build a church on top of the basement. Construction of the current Greater St. John church right next to the old church started in 1977 and was completed in 1981, after which the first church was torn down. The large and modern new church has several wings and two elegant thin spires reaching toward the sky. At the same time, it looks a little like a fortress with its yellow brick walls only occasionally broken by glass block instead of windows. The inside is built of wood and brick, and the sanctuary has a large skylight with a view of one spire. The majority of people of Better Homes belonged to one of these Baptist churches.

Like the two Baptist churches, the Catholic St. Augustine's also had a difficult beginning. When it was organized in 1928, services were held in a refurbished barroom. But it, too, was blessed with a dedicated group of parishioners, especially Sadie Smith, and the additional support of Father George O'Connor from Notre Dame, who had been raised by a black family. With the influx of large numbers of southerners in the 1940s, the parish collected sufficient funds to build a church.

The Greater St. John Choir recently performed the powerful hymn "Lift Every Voice and Sing." Referred to as the National Negro Anthem in the New National Baptist Hymnal, it also is called the African American National Anthem. The hymn speaks both to the importance of faith and to the remembrance of "weary years" this community has known and still knows all too well. Like many African American hymns, it not only praises God and promises a better life to come but also validates African Americans' past, aware of all the hardships they had to overcome and the progress they have managed to make. The third verse begins with these lines:

> *God of our weary years,*
> *God of our silent tears,*
> *Thou who hast brought us thus far on the way*

Reverend Buford Gordon had written that "the most outstanding institution for development of the Negro here and elsewhere is the Christian

An American Story of Courage

Delicate spires contrast with a fortress-like lower part in the Greater St. John MB Church. *Peter Ringenberg, photographer.*

A huge skylight illuminates the sanctuary of the Greater St. John MB Church. *Peter Ringenberg, photographer.*

church…The Negro puts his soul and life in his church work and through it he is able to express his better self."[23] Their ministers serve multiple roles, taking care of their community, fighting discrimination and advocating social justice. In an increasingly secular age, African Americans still see their churches as their homes in a largely hostile world, a world in which they remain separated from the rest of American culture. In their churches, they can affirm their own African American culture and traditions, as well as remember their shared past of "weary years."

Perhaps the most important gathering place for African Americans from 1925 to 1963 was Hering House on Western Avenue near Chapin Street. Buford Gordon's book, which so eloquently pleaded for public places where African Americans could get together, provided the stimulus for Frank and Clarabel Hering to donate such a space in 1925. Frank Earl Hering was Notre Dame University's head football coach from 1896 to 1898, and in their later years, the Herings dedicated themselves to helping the South Bend community. Formerly the First Church of Christ Scientist, built in 1905, the building was renamed Hering House in honor of the donors. It soon became the center for African American community activities of all sorts, from music to sports, as well as political and social meetings. But its central mission was social service and education, as represented by the Urban League and the Our Day Together Club, committed to charitable work and the study of good literature. Hering House provided a welcoming civic center with the mission of improving the lives of its community. It also offered plays, banquets and performances by the H.T. Burleigh Music Association, which was created by Josephine Curtis. The *Hering Herald* kept everyone informed of its many and varied activities.

For the young, Hering House provided a safe and stimulating second home where they could play sports and party as well as learn. Old-timers still remember the Christmas parties and the red Christmas stocking each child received. Gifts were rare for most of them. The stockings were stuffed with nuts and a candy cane, as well as an apple, an orange and one special item, usually a doll for the girls and Legos for the boys. These were all rare treats to be cherished and remembered for a lifetime.

Hering House was led by a series of dedicated directors. Leroy Cobb and his friends fondly remember Reverend John T. Frazier, director of Hering House from 1943 to 1950. Frazier graduated from South Bend's Central High School in 1932 and had himself enjoyed the benefits of Hering House. So when he took over as director, he dedicated himself to the current generation of young people. They loved him, and he had a tremendous influence on them, helping

An American Story of Courage

A Place With Purpose: Hering House, 1925-1963.

This is one of the few remaining images of Hering House as depicted on an Indiana University South Bend invitation card. *Courtesy of Leroy Cobb.*

The Christmas party at Hering House, at which each child received a gift, was one of the highlights of the year. This picture was taken in 1937. *Courtesy of Leroy Cobb.*

them grow into productive and civic-minded adults. As Leroy Cobb said: "Hering House made a better person out of me."[24]

It was only fitting that Better Homes held many of its meetings at Hering House. It was the only place, apart from churches, where the group could

Better Homes of South Bend

Left: This portrait shows Reverend John T. Frazier, a hugely popular director of Hering House from 1943 to 1950. *Collection of Local & Family History Services, St. Joseph County Public Library.*

Below: The 2015 view from Greater St. John to Pilgrim Church shows only empty parking space where once was a vibrant African American business district, including Uncle Bill's Big House and the Liston Hotel. *Peter Ringenberg, photographer.*

gather, but more importantly, Better Homes shared Hering House's vision and purpose. And the community center may well have played a part in Better Homes' success.

Some argue that such separate districts also reinforced segregation and slowed down any efforts at integration. Conversely, however, with desegregation, most of these businesses and the vibrant community around them fell into decline. Helen Pope noticed another unintended result of desegregation: many professional people moved out of their black neighborhoods, which thereby lost important resources.[25] This also is Elijah Anderson's observation in *Street Wise*, his ethnographic study of what he named Village-Northton, where he notes that desegregation deprived the community of its most able citizens. "The weakening of overt housing segregation in parts of the suburbs has allowed blacks to seek better homes and schools elsewhere, leaving Northton without the quality of leadership it enjoyed in the past."[26]

The Chapin Street neighborhood declined in the late 1950s together with the factories and the slum clearance of Maggie's Court and Horse's Alley. However, the Birdsell Street area still grew during that time. As a teenager, Charlotte Pfeifer, who was to become a member of the South Bend City Council, loved to walk about that neighborhood. She was raised in the nearby village of Niles, Michigan, where she always stuck out as a minority. But here she was among many other African Americans, strolling along the busy tree-lined streets, admiring the beautiful homes, shopping and laughing together. She vowed to live there when she grew up. And she did. But eventually the Birdsell Street district also deteriorated as more and more people moved out of the city. Today, the once vibrant area with well-cared-for homes and thriving businesses is mainly empty lots and, except on Sundays, empty parking lots.

4

STRONGER THAN LEGISLATION: JIM CROW IN SOUTH BEND

A man is of more value than real estate.
—*Reverend F.E. Davison, 1943*

Despite our continued and often severe problems with discrimination and racial injustice, it still is not easy for us today to appreciate the full difficulty of what the members of Better Homes were facing in the environment of the 1940s and 1950s. They all suffered daily the humiliation of being treated as inferior. They met Jim Crow at every step: whether they were at work, where they only got the worst jobs, or at home, where they were relegated to the least desirable parts of the city; whether they were shopping and served only after white customers had been helped or could enter city hotels and restaurants only as bellboys and waiters. They were generally treated as second-class citizens.

In the 1940s, Better Homes attorney Chester Allen devoted much of his time to two of the most blatant areas of discrimination: employment and housing. Forty percent of African Americans were without jobs although workers were needed in the defense industries as the country geared up for World War II. In 1941, he managed to get the first six African American men hired at the Bendix Corporation. Still, by November 1941, the company had only nineteen blacks in a workforce of seven thousand.[27] That same year, in his role as state representative, Allen introduced a bill at the Indiana statehouse that would have made it "unlawful to discriminate against employing any person on account of race, color or creed and providing penalties therefore." The bill was defeated, however. Allen had attempted

to speak "for the inarticulate voice of over three hundred thousand colored citizens and taxpayers of Indiana, crying for their chance to provide decent homes for their families by being given employment opportunities in those industries of Indiana which are now working on national defense contracts."[28] In South Bend, only Studebaker among these industries with defense contracts hired larger numbers of African Americans. It helped with the wartime production of the Studebaker US6 two-and-a-half-ton cargo truck; the M29 Weasel, a tracked vehicle for both cargo and personnel; and the engines for the B-17 planes, the Flying Fortresses.

When it came to housing, discrimination ruled as well while the need for African American housing grew steadily more severe. O. Carl McWhorter, editor of the African American weekly *The Elite*, wrote in 1944: "Prior to 1943 no new homes had ever been built for Negroes despite the fact that other groups were able to build homes with very small down payments (10%) through FHA insured loans."[29] And even after 1943, the only new housing for African Americans was temporary—the federal defense homes, which were strictly segregated. Most whites believed that even a single minority family in their neighborhood destroyed property values and ruined the neighborhood's social standing.

One of the chief weapons in the battle to keep neighborhoods white was the racial restrictive covenant. Until 1950, the official code of ethics of the National Association of Real Estate Brokers declared: "A realtor should never be instrumental in introducing into a neighborhood a character of property or occupancy, members of any race or nationality, or any individual whose presence will clearly be detrimental to property values in the neighborhood."[30] In 1950, the association modified its code of ethics by leaving out the reference to race and nationality. However, this did not change the tenor of the code or its basic policy.

The Federal Housing Administration (FHA) participated in this discrimination. Its official manual declared, "If a neighborhood is to retain stability, it is necessary that properties shall continue to be occupied by the same social and racial classes." Therefore, it argued, "Protective covenants are essential to the sound development of proposed residential areas, since they regulate the use of land and provide a basis for the development of harmonious, attractive neighborhoods."[31] There was general consensus about this. In the view of realtors, banks, the FHA and the public at large, harmonious neighborhoods were racially and economically segregated neighborhoods and needed such covenants to prevent infiltration. Between them, they made sure that no one was a

"blockbuster," someone who let an African American family join an otherwise white block of homes.

At the same time, more and more southerners flooded into the city, and it grew ever more difficult for African Americans to find any place at all to live. In 1940 alone, 5,600 arrived from all parts of the South. Many of them could find housing only in downright slums, such as Maggie's Court. In 1945, the *South Bend Tribune* described the place as a "cancer in the heart of the city."[32] In another report, the paper called Maggie's Court the "center of delinquency," saying that it "is destructive of the life of the family, the dignity of the individual, and in time, if not corrected, may be disastrous to our city."[33]

Such degradation did not go unnoticed, and over the years concerned citizens, including Allen, got together to do something about the deplorable conditions that so many African Americans had to endure. They formed a series of committees concerned with housing. There was a housing committee, a housing council, a housing study committee and a housing study group. As early as 1937, a citizens' housing committee argued for a local housing authority to procure federal dollars in support of public housing. The committee, which included representatives from civic, cultural and labor groups, hoped that public housing would end the slum conditions that disproportionately affected African Americans. The group wrote a series of articles in the *South Bend Tribune* in an effort to educate the public and change its prejudice against both public housing and African Americans, who generally were blamed for the deplorable conditions in which they had to live. They showed that African Americans were crowded together in "so-called blighted and slum areas. From 40 to 80 per cent of these dwellings are without even one flush toilet and one bath." The committee also pointed a finger at those responsible. "This concentration is not accidental, but the result of a fixed policy of the real estate board of South Bend and the refusal of white landlords to rent their properties to Negroes."[34] Nevertheless the city council voted against any public housing. The committee refused to give up, and its efforts were supported by the CIO, as well as Mayor George W. Freyermuth and a housing study committee he had appointed. Together they were able at last to move the Common Council to agree to the establishment of a South Bend Housing Authority on March 5, 1941.

This was just in time to qualify for an influx of federal defense housing. Altogether, the government produced two million such units, some for whites and fewer for blacks, in order to quickly house workers in defense industries. However, the Housing Authority's other objective to create one

hundred units in Maggie's Court, which was exclusively African American, was upended by Pearl Harbor and World War II. Slum clearance and the creation of new homes there continued to be fought over for more than a decade. It was only in 1958 that Maggie's Court was finally cleared out.

Once South Bend had its own Housing Authority to act in place of the government in the administration of defense homes, hundreds of housing units came to the city. In 1942, South Bend was designated a "defense housing critical area" by the War Production Board.[35] But immediately, there arose the problem of finding a site for defense homes designated for African Americans. The *South Bend Tribune* phrased it as "housing the city's Negro war workers,"[36] which turned into a highly combative issue. After much debate, the first choice of a site was in the Birdsell Street sector of South Bend, a center of the African American community. It would have displaced forty-six black families and even the St. John Missionary Baptist Church.[37] Allen was among those who objected to this location, and it was not adopted.

Finally, in 1943, another site was agreed on, and it was once again in an African American neighborhood. This was LaSalle Park—or Beck's Lake, as locals still call it. Originally, the area had been part of the Great Kankakee Marsh, 500,000 acres of wetlands and swamp, rich with waterfowl, wild rice fields, birds and beavers. The marsh was named after explorer La Salle, who passed through there on his portage from the St. Joseph to the Kankakee River. Beck's Lake is believed to have been one of the sources of the Kankakee River. When southern migrants began to come to South Bend in larger numbers during and following World War I, the marshy LaSalle Park was the only area where they could buy land. Jim and Mary Cobb from Jackson, Tennessee, were two early settlers when they bought a house at 126 Lake Street in the early 1920s. It had only three rooms: a bedroom, a living room and a kitchen. A central wood- and coal stove heated the little house in winter. There was no indoor plumbing. But they still had open country around them where they could do a little farming. Starting in the 1930s, the city and its industries began to use LaSalle Park as a dumping ground. For decades, the Bendix Corporation discarded its industrial waste there, and the city also dumped its refuse near the lake. Nevertheless, in the 1940s, many other southerners moved into LaSalle Park, and a community of middle-class African American homeowners established itself there, unaware of the soil pollution on which their homes were built and in which their children played. As a result of years of pollution, in 2013, the entire area came under attack for the contamination of its soil with arsenic, lead,

cadmium and other poisonous substances, such as asbestos, solvents, sludge and oils. In December 2013, Beck's Lake was put on the Environmental Protection Agency's National Priorities List. In April 2015, the EPA interviewed residents about conditions in LaSalle Park in order to determine what actions needed to be taken in the "Beck's Lake Superfund site."

In the end, Allen reluctantly supported the LaSalle Park site for the defense homes, although many of its residents opposed it. He gave a moving and truly patriotic reason for his decision: "We feel we are making a sacrifice in agreeing to segregation, but we are willing to take it at the present if it will help the war effort."[38] Allen's statement reflected his attitude throughout his life. He felt a devoted loyalty to his country and an equally devoted commitment to racial justice. He once expressed this dual loyalty in these words: "It is vitally important that the Negro citizen continue his unbroken record of loyalty to America and at the same time militantly insist that he be given his full rights of American citizenship."[39]

Allen's split allegiance is similar to what Du Bois defined in his 1903 book *The Souls of Black Folk* as "double consciousness" affecting all African Americans. Du Bois thought of it in part as the "sense of always looking at one's self through the eyes of others, of measuring one's soul by the tape of a world that looks on in amused contempt and pity."[40] But Du Bois also saw the double loyalty African Americans feel to both America and to their African roots. This results in a "double life every American Negro must live, as a Negro and as an American." In a famous passage of *The Souls of Black Folk*, Du Bois wrote: "One ever feels his two-ness—an American, a Negro; two souls, two thoughts, two unreconciled strivings, two warring ideals in one dark body, whose dogged strength alone keeps it from being torn asunder."[41]

Allen was not alone with his dilemma over public housing. Many leading African Americans shared his mixed feelings about a public housing policy that promoted segregation. The issue had been hotly debated at a mass meeting at Hering House in 1943. In the end, everyone present agreed to support public housing, even though it meant, according to African American attorney Charles Wills, "accepting segregation in its ugliest form."[42]

Federal defense homes like those in LaSalle Park and on Prairie Avenue alleviated a little the pressure on housing for African Americans, but they were far from resolving the crisis. And they could do nothing to improve the slum conditions that prevailed around the factories. This led the Reverend F.E. Davison to say in a sermon on October 25, 1943, at the First Christian Church of South Bend: "I never saw anything in Chicago that aroused my righteous indignation like that which I saw in our city." He described a rat-

infested place, a barn with only a dirt floor. It was divided into four parts by roughhewn boards, and four black families lived there. They paid twelve dollars a month each so that the slum landlord collected what was then the considerable sum of forty-eight dollars a month for this hovel. The reverend ended by calling on his church "to rise and declare that a man is of more value than real estate."[43] Two days later, on October 27, 1943, Reverend T.S. Saunders of the Pilgrim Baptist Church added that if anything, Davison had understated the conditions that Saunders found "hideous beyond the power of words to describe." He gave details of a basement with "ten or twelve beds along an open space beside a damp, dirty wall on a cold concrete floor where dampness and offensive odor from a single toilet makes one shut off one's breath when one enters."[44]

Living in proximity to Maggie's Court, the Better Homes group could see conditions there for themselves. They also were avid newspaper readers and followed the battles over housing and its racial controversies in the local paper. The *South Bend Tribune* at least gave relatively unbiased reports of all sides and even on occasion pleaded against racism. In other nearby areas, however, the local press was vociferous in its support of discrimination. The *Calumet Index* of June 9, 1947, carried a column entitled "Protect Your Homes":

> *Negro interests in the state have again seen fit to try to force themselves on the white population by having bills introduced in the state legislature which would wipe out all property restrictions. Unless these bills are defeated, every white neighborhood in the city and state will find itself defenseless against the wanton destruction of property values by a Negro minority intent upon forcing itself upon white neighborhoods.*[45]

Housing segregation only intensified after World War II. Any white family who was at all able to do so fled to the suburbs, and they fought fiercely to prevent any infiltration of minorities there. As a result, the west side of South Bend, starting from the Studebaker and Oliver factories, became almost exclusively African American. This white flight took with it private and public investment in housing, schools, roads and infrastructure, leaving a deteriorating center to the poor.

As Buford Gordon already had noticed, public sentiment was stronger than legislation. Discrimination in both employment and housing continued unabated in the face of a series of laws passed by Congress and presidential executive orders against it. This meant that all those who engaged in racist behavior despite legislation prohibiting it acted in a radically anti-democratic

way and in defiance of American values. Yet they saw themselves as patriots, protecting their country and what it stands for.

To create fair employment, President Franklin D. Roosevelt issued Executive Order 8802 on June 25, 1941, which said that "there shall be no discrimination in the employment of workers in the defense industries or government because of race, creed, color, or national origins."[46] To ensure compliance, the president created a Committee on Fair Employment Practices to oversee complaints. Nevertheless public sentiment was so powerful that companies were willing to risk national security rather than hire African Americans.

In matters of housing, the federal government introduced a number of laws to prevent discrimination. In 1949, Congress passed the National Housing Act. A preamble declared its aim of providing "a decent home in a suitable living environment for every American family." This was followed a year later by the creation of the National Committee Against Discrimination in Housing. Seven years later, in 1957, the Civil Rights Commission came into being. In 1962, Kennedy signed Executive Order 11063 on Equal Opportunities in Housing.

In *As Long as They Don't Move Next Door*, Stephen Grant Meyer squarely put the blame for this continued racism on the public at large: "The history of almost continuous racial conflict over housing in the twentieth century evinces not so much a problem of inadequate enforcement by government agencies or the inadequacy of the laws themselves as a determined effort on the part of white homeowners, landlords, and tenants to keep their neighborhood white." He argued that "if neighborhood improvement associations and individual homeowners demonstrated a ready acceptance of, or even just indifference to, black in-migration, then realtors and government officials would have neither the will nor the need to pursue segregationist policies. Instead the conflict over residential space demonstrates that laws and institutional discrimination followed the violence and resistance to integration. They were remedial actions taken to restore peace, order, and stability to neighborhoods."[47]

The controlling power of public sentiment in enforcing discrimination was highlighted by the postwar development of the planned communities of Levittown, the first postwar American suburbs and the models for the spread of white suburbia. Builder William Levitt, son of the company's founder Abraham, justified his exclusion of African Americans by saying: "As a Jew I have no room in my mind or heart for racial prejudice. But…I have come to know if we sell one house to a Negro family, then 90 or 95

percent of our white customers will not buy into the community. That is their attitude, not ours."[48]

With such powerful emotions against them, the members of Better Homes must have felt that their dream of homes in a nice neighborhood was almost unattainable. How could they possibly win out over this overwhelming power and prejudice? At the very time when the group was debating their prospects of finding better housing, one local case brought their difficulties into sharp focus. In the latter part of 1949, Dr. Bernard Vagner and his wife, Audrey, experienced South Bend's housing harassment. Dr. Vagner was a graduate of the prestigious Meharry College in Nashville, Tennessee, with an additional five years' experience in general surgery, and his wife was trained as a teacher. He was coming to South Bend to work as general surgeon, and they were looking for a house to buy for their growing family. Mrs. Vagner consulted many realtors, but "in every instance when I asked about a house I was always offered to be shown a house in an all-Negro neighborhood." She went to her bank looking for an estate sale and was told about a house that was to be ready soon. A week later, however, the bank informed her that the house, even once available, could not be sold to her. "I was shattered, completely shattered."[49]

At this desperate moment, an African American realtor called William Morris offered to help them. A graduate of South Bend's Central High School in 1939—when, incidentally, John Wooden was basketball coach—he had been a member of the renowned Tuskegee Airmen, the first corps of African American combat pilots. Morris was just starting out as realtor, although as an African American, he had been excluded from the Board of Realtors. Instead, he had to call himself a "Realtist." From the beginning of his career, Morris dedicated himself to fair and open housing.

Morris found two lots for sale at the corner of Jacob and Campeau Streets that suited the Vagners. It was an essentially white neighborhood, although Morris's office was just two blocks away on Chalfant Street, where he also had developed eleven houses for African Americans. The Vagners hoped that buying land and building on it would be easier than purchasing an existing home. The lady who owned the lots was at first eager to sell.

> *She met us at the door with the deed in her hand, but obviously she had not known we were Negroes. I could tell this from the reaction; we all could. She started retreating from her former position of wanting to sell and started making excuses. She blamed the neighbors...she thought she had better take a canvas of the neighborhood to see how they felt, which she did. Now she*

was only contemplating selling, but someone got wind of it and the "For Sale" signs started going up.

In the end, the Vagners gave up. In April 1950, just a month before Better Homes was founded, they rented the former home of dentist Dr. B.W. Streets at 324 Birdsell Street in a mixed white and black neighborhood, two blocks from an African American business district.

In the years ahead, Morris never relinquished his fight for fair and open housing. In 1954, he became president of the local NAACP. And yet that very same year, as well as in 1959 and again in 1964, he was denied membership in the South Bend–Mishawaka Board of Realtors in a secret ballot.[50] Even so, Morris went on to an illustrious career. From 1969 to 1977, he served as national director of housing for the NAACP and became a powerful force for low-income housing across the United States. Working with the Federal National Mortgage Association, Morris was appointed special advisor to the president on Urban Affairs and director of the National Association of Real Estate Brokers.

Even closer to the date when Better Homes was about to act, members read two pieces in the newspaper that showed them how powerful prejudice was in the city. On February 28, 1950, the *South Bend Tribune* reported that the South Bend City Council refused an $11 million federal grant to build 1,023 low-rent public housing units, most of which would be for African Americans who were in most need of them. Public housing was seen as a euphemism for both black housing and "creeping socialism." Again on April 4, 1950, the city council turned down a $3 million federal grant for 332 units of public housing. This was just one month before the Better Homes group got started. In each case, Republican members vetoed any public housing, even at the cost of losing millions of federal dollars.

The councilmen were not alone in their hatred of public housing. Joseph Wentland, chair of the Citizens Committee against Public Housing, called it "socialized political housing," saying that those in favor were trying "to foist public housing on the people of South Bend." He did not shy away from using the war service of U.S. soldiers in the less than three-month-old Korean War in his argument: "Our servicemen believe that they are being asked to fight and die so that democracy and the American way of life may live. Socializing our country during their absence would be scant gratitude for their supreme sacrifice."[51] "Our servicemen" obviously did not include the thousands of African Americans already fighting in the Korean War.

Better Homes of South Bend

If discrimination and racism were bad in South Bend, they were even worse in larger cities like Chicago. Between 1949 and 1951, "there had been three bombings, ten incidents of arson, eleven incidents of attempted arson, and at least eighty-one other incidents of terrorism and intimidation."[52] One such instance happened in July 1951, when the Clarks, a college-educated couple from Mississippi with two small children, rented an apartment in all-white Cicero, a suburb of Chicago. An enraged mob of around four thousand burned all their belongings and destroyed the apartment. When the Clarks still did not give up, a riot ensued, with the crowd chanting, "Go, go, go!" The rioters firebombed the apartment house, gutting it and forcing its white residents to seek refuge. Illinois governor Adlai Stevenson had to call in the National Guard to quell the violence.[53]

Lorraine Hansberry's play *A Raisin in the Sun* deals with the same issues. At the beginning of the play, the black Younger family has just fulfilled their American dream and bought a home so that they could move out of the projects. It was in the all-white working-class neighborhood of Clybourne Park in Chicago. However, the local neighborhood association—or, as it calls itself, the Clybourne Park Improvement Association—sends Karl Lindner, chairman of the "Welcoming Committee," to keep the Youngers from moving into their house. The diffident and hypocritical Mr. Lindner pressures the family—"you people," as he keeps calling them—with incentives and disguised threats, claiming, at the same time, "I want you to believe me when I tell you that race prejudice simply doesn't enter to it. It is a matter of the people of Clybourne Park believing…that for the happiness of all concerned that our Negro families are happier when they live in their *own* communities."[54] His trump card is that he offers to buy them out for more than they originally paid for the house. When that doesn't work, he threatens them: "People can get awful worked up when they feel that their whole way of life and everything they've ever worked for is threatened."[55] At the end of the play, the Youngers reject Lindner's offer and get ready to move, determined to be good neighbors in this unwelcoming environment.

It could be said that the Youngers in Hansberry's depiction fared better in 1959 Chicago than the Vagners did in 1950 South Bend. The Youngers were able to buy a house in a white neighborhood, and they did make that move. Yet in light of their neighbors' attitudes, their future is, at best, uncertain. Hansberry later described what happened to her own family when they, like the Youngers, moved into a white Chicago

neighborhood. In a letter to the *New York Times* of April 23, 1964, she said that her family moved into

> *a hellishly hostile "white neighborhood" in which, literally, howling mobs surrounded our house. One of their missiles almost took the life of the then eight-year-old signer of this letter. My memories of this "correct" way of fighting white supremacy in America include being spat at, cursed and pummeled in the daily trek to and from school. And I also remember my desperate and courageous mother, patrolling our household all night with a loaded German Luger (pistol), doggedly guarding her four children, while my father fought the respectable part of the battle in the Washington court.*[56]

Discrimination and persecution were directed against all people of color, not only regular African American citizens. In 1948, the famous star Nat King Cole faced the same situation in Los Angeles as the Youngers had in Hansberry's play. The local neighborhood association tried to buy him off with an extra $25,000 for the house he had purchased if only he would leave. Cole refused and faced the neighbors' tactics of persecution.

This was the climate when the Better Homes group got together with its hopes and dreams. The question was whether its dreams would turn into "a raisin in the sun" or whether, by chance, they would become dreams realized, not "dreams deferred." Hansberry's title is taken from the 1951 Langston Hughes poem "Harlem," which begins with these lines: "What happens to a dream deferred? Does it dry up like a raisin in the sun?"

5

HOMES IN A WHITE NEIGHBORHOOD

The beauty and advantage of the prospective site.
—*Lureatha Allen, June 1950*

The second meeting of Better Homes took place on Sunday, June 4, 1950. After members said the Lord's Prayer in unison, Allen told them that papers needed to be drawn up as soon as possible so that they could receive their charter of incorporation. He also urged them to make a decision about placing an option on the lots that he had mentioned at their first meeting, each of which cost $375. This seems like a very quick move, but probably the site had been considered for a while. It is not clear whether Allen found these lots on his own or whether the group had chosen them together. What is clear is that all of the members wanted to move as quickly as possible to secure the lots.

Next, the president, Lureatha Allen, summarized for those who weren't there before "the beauty and advantage of the prospective site." The lots were located on the 1700 to 1800 block of North Elmer Street in the Marquette Heights Addition, five blocks from Marquette Elementary School in a white neighborhood. However, the actual location of the site was not mentioned in the minutes because of the necessary secrecy. Aware of the precariousness of their situation, they didn't want word to get out before they were ready to make their move. Just a year before, across the border from them in St. Joseph County, Michigan, African Americans had succeeded in buying land to build homes only to be faced by a newly created

Better Homes of South Bend

Lincolnway West runs at the bottom of this 1941 map. In 1950, only two African American families lived north of it. The Better Homes blocks stretch between Keller and Hamilton Streets. *Collection of Local & Family History Services, St. Joseph County Public Library.*

zoning ordinance. It stipulated that no one could build on parcels of fewer than twenty acres, so they were unable to build their homes.[57]

If Better Homes succeeded on North Elmer, its members would be the first African Americans in that middle- and working-class neighborhood. Lincolnway West was then the unofficial boundary. Only two black families lived north of it. Dentist Dr. Guy P. Curtis and his wife, Josephine, were in the first block north at 1053 North Elmer Street, and attorney Charles A. Wills lived on North Olive Street. Up to the 1600 block, North Elmer was pretty well settled but only by white folks, many with Polish, Hungarian or German names. Three years later, when African American physician Dr. Ronald Chamblee wanted to buy a house in the lower blocks of North Elmer Street, the white homeowners' lawyer turned him down.

In 1950, the 1700 to 1800 block of North Elmer Street had only a handful of white residents. There were five houses in the 1700 block and one in the 1800 block, and nothing north beyond that up to Lathrop Street and the adjoining Highland Cemetery. The cemetery is locally famous for its Council Oak, under whose shade the French explorer La Salle is said to have held meetings with Indian leaders in 1681. In the twentieth century, many African Americans, including Chester and Elizabeth Allen, were buried in Highland Cemetery, but they were segregated from the white population even in death. The African American plots are on the south side of the cemetery adjacent to Lathrop Street.

All but one of the already existing houses in the 1700 block of North Elmer was on the west side of the street. The first home at 1705 belonged to Clarence Hagedorn, a World War I veteran and Studebaker employee. It was a "basement home," a house that was nothing but a basement with a slab above. Hagedorn had lived there since 1938. Hagedorn's daughter, her husband and their many children had moved in as well. For lack of space in the home, the family had a yellow bus, in which their grandfather slept, parked on their property. Clinton Carson lived at 1721 and Randall J. Murphy at 1727, the only one of the first houses that still stands today. Raymond M. Minder's home was at 1741 and Theo Hagedorn lived at 1742. However, he left when Better Homes came, after which the house stood vacant. The only house in the 1800 block was at 1838 and belonged to William Johnson, who had moved in a year before Better Homes started. After his death in 1951, his wife, Clotiel, stayed on there. Beyond the 1800 block, there was nothing but open country.

In order to secure a lot, each member of Better Homes had to make an initial payment of $100, half of which was due in just a week from the second

meeting, on June 13, and the other half on June 20. After that, the remaining $300 had to be paid as soon as possible. The group decided that to entice everyone to pay up quickly, the sequence in which each paid the full amount of $400 would determine the order in which lots could be chosen. This was another indication of how the group was thinking ahead, establishing these rules even before the option was placed.

At the end of the meeting, Allen announced that he had contacted DeHart Hubbard, a man who would work hard on their behalf, from the FHA in Cleveland. The FHA had finally yielded to pressure from civil rights groups by ruling that it would no longer insure mortgages with racial restrictive covenants after February 1950, although it continued to insure properties with previous covenants. Presumably the Cleveland office had created the position of race relations advisor and hired Hubbard in that role in order to mend fences.

The group met every day of the weekend of June 9, which turned into the biggest, most successful days in its young history. Group members met first at Lureatha Allen's home; next at Robert Taylor's on 1321 Prairie Avenue; and on Sunday, June 11, at John Fleming's at 1327 Prairie Avenue. Their first task was to finalize the bylaws. They debated the constitution of the board of directors and various committees, especially the membership and appraisal committees. In order to maintain the group's thoroughly democratic procedures, they passed an amendment that provided that the soon-to-be-elected board of directors could only recommend a course of action but that any action needed the consent of the membership body. Another amendment stipulated what they had already done at each meeting, to hold "a short devotional period to open the meeting, preceding regular business." After that, the bylaws were accepted unanimously. The Better Homes leadership saw to it that all proceedings were conducted in an orderly manner and that they followed strict and democratic procedures throughout.

On Sunday, June 11, they got together in the afternoon after church and lunch and accomplished a great deal that moved their organization forward. First of all, the treasurer and the secretary formed a committee to sign for the land options. They used $700 from the treasury as option money for the site. One reason that made the area so attractive was the large number of plots available both on North Elmer and the adjacent North Olive Street. From the start, Chester Allen—and perhaps the Better Homes officers, as well—was looking to build as great a number of homes as they could. Next, they chose three members—Arnold Allen, Ruby Paige and Robert Taylor—to sign the articles of incorporation.

An American Story of Courage

At this point, twelve people had paid the first instalment of $100. With the exception of Bozzie and Lila Williams, all were officers of Better Homes. They were Clint and Cleo Taylor, Marcus and Lelar Cecil, Arnold and Lureatha Allen, Robert and Louise Taylor, Gus and Josie Watkins, Wade and Beautha Fuller, Earl and Viro Thompson, Bland and Rosa Jackson, John and Millie Fleming, Bozzie and Lila Williams, Sherman and Ruby Paige and William and Katherine Bingham.

Next, they elected an eleven-member board of directors. Four of them were to serve one year, four to serve two years and three to serve three years. Chester Allen was to be the resident agent for the board as well. Beautha Fuller, Robert Allen and Florence Adams were elected for one-year terms. Two-year members were Clint Taylor, Millie Fleming, W.C. Bingham and Gus Watkins. Louise Taylor, Lureatha Allen, Bland Jackson and Marcus Cecil were elected for three-year terms, with Cecil as chair.

It is noteworthy that five out of the eleven board members were women. That number increased to six in August 1950, when Clint Taylor asked to be replaced by his wife, Cleo. The couples worked closely together, and one of the reasons for the number of women on the board was that some of them stayed home and had more time to spend on the group than did the men. Just the fact of having more time, however, was not the only reason women played such an active part in Better Homes. In her book *Collective Courage*, which deals with the history of African American cooperatives, Jessica Gordon Nembhard stressed that "African American women played significant roles, held leadership positions…across almost every kind of organization…women were instrumental in organizational development, fund-raising, day-to-day coordination, and networking for cooperatives as well as other organizations."[58]

The women of Better Homes, whether they were officers or just members, bore this out. They were active in the many educational and civic organizations that are uniquely characteristic of American society. Many of them participated in the Urban League of South Bend, which had a mixed membership of whites and blacks. Ruby Paige, Cleo Taylor and Ruth Chambers served in the Urban League, and Ruth was elected to its board in 1960. She also belonged to the African American Our Day Together Club. Geraldine Coker was president of the St. Pierre Ruffin Club in 1954–55. The club, started in 1900, had the motto "A Noble Deed Should Never Be Delayed." It dedicated itself to education, literature, social service, music and art. St. Pete's, as it was popularly known, was said to have been the premier African American club in South Bend.

Better Homes of South Bend

Eugenia Braboy, who became prominent through her community service, was indirectly associated with Better Homes since she was the mother of one of the members. Her son, Schyler, and his wife must have been close to the elder Braboys, for the men always worked together, first at Studebaker and then at the Mar Main Apartments. The two families shared a duplex building at 413 College Street. Eugenia Braboy, the first black elevator operator at Penney's, served as president of several organizations, including the Urban League and the Federated Club Women of South Bend, and she was active beyond South Bend in the Indiana State Federation of Colored Women's Clubs.

Chairman of the board Marcus D. Cecil of 1517 West Washington was by far the oldest member of the group. He was born in 1880 in Fort Gage, Illinois, on the Missouri border and came to South Bend in 1941, when he was sixty-one years of age. Nevertheless, in 1950, he still worked as an assembler at Studebaker. He had married Lelar Jefferson in 1916, and the couple had two sons and four daughters, all of them grown by the time he was in South Bend. Lelar did not work outside the house. Marcus was part Indian and proudly talked about his heritage. He was particularly excited about the Better Homes initiative since he told the group that at age seventy, "I have never owned a home before."

Two-year board member Gus Watkins of 1309 Prairie Avenue was born on October 23, 1923, in Macon, Georgia, an industrial river town much like South Bend. He came to South Bend in August 1943 to work at Studebaker. Gus Watkin's wife, Josie, also was from Georgia and probably from Macon as well. They had five children, and Josie stayed home to raise them. Growing up in Georgia, Gus already was a devoted church member. In South Bend, he joined the Macedonia Missionary Baptist Church on Cotter Street at the southern edge of the Studebaker plant. Over the years, he served his church in many capacities, including usher, trustee, president of senior ushers, youth leader and director of the junior usher board. He was a delegate of the National Usher Board Division to the National Baptist Convention. He obviously enjoyed clubs of all sorts, belonging to the Martin Luther King Senior Men's Club, the Lincolnway Grill Breakfast Club and, for over fifty years, St. Peters Lodge No. 31 F and A.M. Prince Hall affiliation.

William Bingham, another two-year member, lived with his wife and three children at 1308 Chapin Street. Both were from Jackson, Tennessee. William was born in 1924, served in World War II and afterward attended Lane College on the GI Bill, graduating with a bachelor of science degree

in 1948. He came to South Bend right afterward in search of a good-paying job. Although he had a college degree, Bingham started out as an assembler at Studebaker. As his son, Keith, explained, he did so because "discrimination successfully kept people of color out of municipal, county, and state jobs." But when pressure from the federal government forced the county welfare department to hire minorities, William Bingham was the first African American caseworker in the St. Joseph County Welfare Department. William and Katherine had three children, Kathy, Bonita and Keith. His wife did occasional work outside the house as a domestic and on the assembly line of Wheel Horse Corporation.

Beautha Fuller lived at 1329 Prairie Avenue. She was born on November 30, 1918, in Union Springs, Alabama, a village of about three thousand people. Until the 1920s, there were cotton plantations around Union Springs, most of which were turned into game preserves for hunting since Union Springs had no river access or other means of transportation. Beautha came to South Bend in 1942 and married Wade Fuller in 1948. Wade was a laborer at Studebaker who had come from the same town—Indianola, Mississippi—as Sherman Paige. They had three children: Wade Jr., Roosevelt and Nancy. Like Florence Adams and Louise Taylor, Beautha Fuller stayed at home looking after their children.

Leroy Cobb and his wife, Margaret, had just joined Better Homes the weekend of June 9. Leroy was very much impressed by the complexity of the proceedings and the methodical and democratic way in which the group handled its affairs. He had never participated in anything like this before. So he listened carefully and absorbed it all. During the course of its existence, Better Homes provided many life lessons for the young man and helped him to build a successful future for his family.

Leroy worked at the Studebaker foundry, where he had started at age eighteen, immediately after graduating from Central High School in June 1948. On his first day at work, he was put on the "shake out" line, where the metal was shaken to let any dirt drop out. Hot metal was poured into molds farther up the line. When it came to Leroy, his job was to pick up the red hot metal with a long hook and fling it into a hopper. Four hundred tons of metal could be poured each day at the foundry. That first day, Leroy worked together with two men old enough to be his grandfathers. They labored in silence for a while, but soon the old men called to the foreman: "Stop the line and take that boy off. He'll get hurt." The foreman looked at young Leroy and did as the old men had said. From then on, Leroy was assigned to less dangerous jobs in the foundry, such as sorting materials and delivering

BETTER HOMES OF SOUTH BEND

The Studebaker description says: "A compensating supply air curtain and an adjustable louvered exhaust hood confine and exhaust pouring fumes." But plenty of fumes and heat remained in the foundry. *Studebaker National Museum Archives.*

them in a towmotor. Today, Leroy says, "The work was hot and dirty, but the pay was good." Studebaker workers belonged to the UAW, and Leroy made seventy-two dollars a week, which was a considerable amount at that time. At eighty-five, Leroy Cobb still expresses his gratitude to the union. "I will always be a union man."

After only two weeks on the job, Leroy married Margaret, a woman he had known for most of his life. Margaret had lost both her parents early and had to live with her sister in the slum of Maggie's Court. The little houses of the long U-shaped court went right up to the dirt road, with Clarence Elliot's Pool Room at the entrance. There was not even a bed for Margaret, so she had to sleep on the floor. Margaret and Leroy chose Reverend Frazier from Hering House to perform the wedding ceremony. He not only married them but also gave them a piece of advice that stayed with Leroy for the rest of his life. The minister told them that their first action as a married couple should be to open a bank account and start saving every week. The young couple lived in one room of his

An American Story of Courage

This image depicts the Studebaker foundry iron pour, where so many African Americans started out. "Front slagging spouts drain slag into a common sluice." *Studebaker National Museum Archives.*

mother's house on South Laurel Street within sight of Studebaker. At the time of the June 11 meeting, Margaret already had given birth to their first child, a son named Leroy Jr.

Better Homes of South Bend

Leroy Cobb remembers vividly the first time he saw the stretch of largely empty gravel road on North Elmer where the lots for Better Homes were located. He went there together with his best friend Willie Gillespie, "one of the nicest fellows you'll ever meet." Willie had come to South Bend from Memphis in 1943 to work at Studebaker. Together they took the bus to Huey Street. From there, they walked up the short hill and soon found themselves on Olive Street. They had gone too far and had to backtrack a block to find the empty stretch of North Elmer Street. And there it was: beautiful, largely unspoiled land and a gravel road with embankments on either side for their houses to sit on. In contrast to the factories, railroad tracks and Maggies's Court, it was a lovely place to live. Looking at the pretty stretch of road, Leroy had high hopes about a better future, but at that point, he wasn't at all sure that they would become reality.

6

THIS LAND IS OUR LAND

The deed for 18 lots would be in our possession this afternoon.
—*J. Chester Allen, August 5, 1950*

Shortly after that busy weekend of June 9 to 11, Better Homes of South Bend achieved its first milestone. On June 18, it successfully placed an option on twenty-six lots on North Elmer Street, which they could buy from the county for $350 each. To secure the option, a payment of $9,100 had to be made within ninety days.

Leroy Cobb believes the main reason that the group succeeded in buying the lots without opposition was that it was undeveloped land at the edge of the city. The few white people who lived there were themselves working class. But then, it often was the white working class who fought most fiercely against African Americans moving into their neighborhood. At any rate, the minutes convey no hint of an obstacle overcome. But then Better Homes was still cautious and sensitive to potential problems ahead and kept the minutes as plain as possible.

One indication that the group might, after all, have felt buoyed by success is that it contemplated right away placing further land options. In particular, members had their eyes on fifteen lots on North Olive Street, the next street to the west of North Elmer. The lots had a lien against them, but they would become available within ninety days. While waiting for this, the Better Homes officers' main goal was to get every member to pay the remaining $300 of their $400 share.

At this milestone meeting, they also agreed to use $210 from the treasury to purchase their charter and file their documents with the state so that

their corporation would be official. Allen handled all the legal steps. He also suggested that they list his office at 416–418 Lafayette Building as the corporation's permanent office and designate him as resident agent. His proposal was accepted unanimously. Now that Better Homes had the land options and was on its way to become incorporated, the group could focus on the heart of its mission. Its members were ready to think about what kinds of homes they could build, and they ordered plans from the Standard Home Company to check on options and house plans.

The first board of directors meeting took place on Saturday afternoon, July 1, 1950, at the home of the Allens. Marcus D. Cecil presided as chairman of the board. Chester Allen began by explaining the advantages of being a corporation. He wanted to be sure that everyone understood the procedures that were underway. While his arguments were not recorded in the minutes, he likely told them that they had a much better chance of getting their homes built if they acted as a corporation. They all knew already that getting loans in a white neighborhood would be a major problem. A corporation, however, could put more pressure on banks than an individual buyer. It also could handle more effectively the negotiations with builders as well as the city. After Allen had answered all board members' questions, the charter was approved and the bylaws accepted "to be written in book form" at Allen's office. Now that Better Homes was going to be a corporation and had secured its land options, it could go a little more public with a seal and a formal letterhead for its correspondence, listing the name of the corporation, its officers and the members of the board of directors.

All board meetings were held not at Hering House but in one another's homes, and meeting times were set between 8:00 and 9:00 p.m. Throughout its existence, the board got together frequently, sometimes as often as every week or, when necessary, even every few days. In the late summer of 1950, for example, the board met on August 4, 12, 15, 23, 25 and 28 and in the fall of that year on October 4, 6, 10 and 19. After a grueling day's work in the factory, it must have taken all their strength to concentrate on the complicated financial issues, negotiations with banks and contractors and the elaborate and drawn-out process of getting improvements from the city.

On July 9, 1950, there was another general meeting of Better Homes. The officers wanted to make sure that members were informed at all times of what was happening. For that purpose, the secretary read them the minutes of the board of directors meeting of July 1. Next, the group was told that the corporation had received its charter and that Treasurer Bland Jackson had been placed on a $10,000 bond, obtained on June 20, 1950. Just over one

month later, on August 5, 1950, the corporation reduced the bond to $5,000, saving itself $50. Having a bonded treasurer was another sign how careful Better Homes was. The bond protected the corporation's money and also assured lending institutions that their investment was safe. At the end of the meeting, Allen announced that at the next general meeting, a representative from the FHA would be present, which was to be a major event.

The board of directors met again on Wednesday, July 12, 1950. Their main concern was to impress on all members the urgency of paying the outstanding amounts for their lots before the ninety-day option, which had begun on June 18, expired. They were well ahead of the deadline but wanted to have everything in order to avoid last-minute crises or give the county any reasons to withdraw the option after all. To speed things along, the board decided to send a letter to any member not yet fully paid up. The pressure of this deadline weighed on them for several meetings. Next, the board created a Construction and Development Committee, consisting of Fred Coker as chairman; Chester Allen as counsel; and William Bingham, Arnold Allen and Lureatha Allen. Fred Coker was the only member of this group who was not a Studebaker employee. In 1950, he worked as collector for the city waterworks. Before that, he had done stints as deputy sheriff and as porter in the People's Funeral Home.

The much-awaited event of the July 16 general meeting was the first appearance of DeHart Hubbard from the Cleveland office of the FHA. Hubbard explained FDIC insurance regulations and told them that since the government was ready to insure 90 percent of their loans, banks had to provide mortgages as long as everyone's credit was good. He went on to outline FHA services available to them, such as architectural, inspection and appraisal services, the latter with a charge of twenty dollars.

There can be no doubt that the handsome and well-dressed forty-seven-year-old man impressed everyone. He was the first African American to win an Olympic gold medal in an individual event: the running long jump at the 1924 summer games in Paris. He was then a student at the University of Michigan, from which he graduated in 1927. This in itself was an achievement since only 8 out of the 1,456 graduating students were African American. And now this famous person had come to meet with Better Homes to help with the complexities of financing.

Leroy Cobb, too, was most impressed by DeHart Hubbard's knowledge and demeanor. It meant a lot to him that here was a representative of a federal agency vowing to help them. Leroy had never heard of FDIC insurance and was thrilled to hear Hubbard say that he was committed

"to guide us along, especially with the financing." Listening to the FHA representative on that day suddenly gave Leroy the confidence that with this man's help, they would be able to fulfil their dream and that Margaret and he would have a brand-new home of their own in a nice neighborhood as he had imagined ever since he first saw the site and joined Better Homes.

Three days after Hubbard's appearance, the board was preoccupied with collecting the remaining $300 from each member. Most had come up with only the initial assessment of $100. "The necessity of paying the balance of the assessment was stressed so firmly that the members agreed to pay theirs immediately," according to the meeting minutes. To put on more pressure, each member of the board was assigned to contact one general member of Better Homes and ask them to pay their balance right away. In order to avoid any such problem in the future, it was agreed that newcomers would have to pay their $400 immediately upon applying for membership.

At the July 25 meeting, the board was still working on getting everyone paid up. In an effort to move things along, Chester Allen enticed the group by saying that if at least fifteen members were fully paid in, "the deeds of the lots could be obtained in manner of payment." He expressed the hope "that homes could be constructed likewise." It worked. More members paid up, and at the next board meeting on July 31, Allen could announce that the deed to eighteen lots would be ready on Friday, August 4. But he also suggested that they needed to continue their frequent board meetings until enough money was paid into the treasury to consider advancement on construction and that it would be a good idea to get started with the sixteen lots already paid for by then. The urgency of this was motivated not only by everyone's eagerness to move into their new homes but also by the underlying fear that something would block their venture.

As Allen had promised, at the board meeting on August 5, 1950, he could give board members the good news that "the deed for 18 lots would be in our possession this afternoon." A week later, they could actually hold in their hands the warranty deed for 18 lots on the 1700 and 1800 block of North Elmer Street. The lots cost $6,300, which the corporation paid from the moneys members had paid into the treasury for their lots. Here was palpable proof of the success of their efforts, the dream no longer deferred but at last beginning to be realized. Everyone wanted to touch and inspect the precious warranty deed, which at this point was handled in the name of the corporation. Individual families received their own deeds only when they had secured their individual mortgage loans. Looking ahead to the completion of their mission, Chester Allen explained that as soon as

members received their own deeds, they would automatically lose voting power in the corporation, and so, step by step, its work would be done.

The lots were purchased through George Sands, for forty-six years a prominent white lawyer in South Bend and Allen's friend. Sands must have been sympathetic to their cause and had perhaps heard about it not only from Allen but also from his African American colleague J.W. Thomas, with whom he shared an office in the Odd Fellows Building. Sands was born in Bainbridge, Ohio, on February 22, 1888, and came to South Bend at the age of seventeen to attend Notre Dame Law School. Immediately after graduation in 1910, he opened his law practice in South Bend. In 1912, he was elected as the state's youngest legislator and introduced a bill that began construction of Healthwin Hospital, the very place where he died in 1972. His obituary noted that "in his fledgling years as a lawyer he was known as the 'boy orator' who cast a spell over a courtroom with his eloquent command of the spoken word." It went on to describe Sands as "this wise young man who commands his English with the authority of a field marshal of language."[59] Throughout his career, Sands remained a power in local Democratic politics.

George Sands was not the only attorney who worked with Better Homes. Edgar Anderson also helped the corporation with options on the additional lots. Anderson was born in Mishawaka in 1889 and had an extraordinarily long career as an attorney in South Bend. He was a member of the St. Joseph County Bar Association for over fifty years. Leroy Cobb remembers dealing with Anderson repeatedly and that he appeared to work out of the courthouse. He might have been hired by the city to negotiate with Better Homes on some aspects of buying the lots, but he was neither a city nor a county employee. Most likely, Anderson was another lawyer used by Better Homes in an effort to move its affairs forward.

With the warranty deed for eighteen lots secured, the group was elated by its achievement. The members felt ready to acquire more lots and were confident that they could find additional members to purchase them. So the board accepted the option for eight further lots on North Elmer Street at a cost to the corporation of $2,800, which was due by October 20, 1950. And it considered an additional option for fifteen lots, also in the Marquette Heights Addition, for $6,270 to be paid by December 20, 1950. At the same time that Better Homes relished its success, however, the group also was aware that it still had many obstacles to overcome.

7
Impasse

Nobody wanted them to build on that land.
—Nola Allen, 2015

The success of buying the lots was soon overshadowed by resistance from many quarters. As one might have expected in the climate of the times, the white residents of the North Elmer Street area did not like the prospect of a group of African Americans moving into their neighborhood. This, at least, is the assessment of Nola Allen, who heard about the difficulties from her mother. In Nola's opinion, "Getting the land was the easiest part, but after that nothing was easy. Nobody wanted them to build on that land." Leroy Cobb agrees, "We had to manage all kinds of opposition."

In a process that took three years, surveyors, contractors, lending institutions and the city all seemed to move slowly or impose conditions that were difficult for Better Homes to meet. However, no details were recorded, perhaps because the group continued to give out as little inside information as possible. Nola Allen has another reason for this silence. In her view, the Better Homes leadership, especially her mother and Chester Allen, kept to themselves as many of the problems as possible in order not to frustrate members even more by the delays. Thus, there was little specific evidence of their difficulties beyond an urgency to get things settled and occasional references to the increasing disillusion among its members. At most, you can read between the lines that there was concern among the leaders of Better Homes: they stressed the importance of making payments well before the deadline; they repeatedly reassured members that they were

making progress; they admonished everyone to stay together and warned of the danger of destroying their corporation. The only outright mention of a problem occurred on January 5, 1952: "A letter was read from Irving Trush in answer to a letter of a much earlier date in which they refused a loan." A financial institution not only had turned Better Homes down for a loan but also had made it wait a considerable time for an answer.

Instead of dwelling on the reasons for the delays, the group concentrated on a choice of contractors, although here also Better Homes ran into problems. Belleville, Swanson, Colpaert and Hartman were mentioned first. They must have had mixed feelings, especially about Colpaert since the company was known to build nice homes for white families on the south side of Western Avenue and cheaper ones for African Americans on the north. Colpaert used the same double standard in the better homes on Corby Street and the cheaper ones in LaSalle Park. This was rather common practice. Place and Co was known to use two-by-four wood construction for white and only one-by-four for black homes. Leroy Cobb remembers that one potential contractor refused to put doors on the closets of their houses. In a flurry of special board meetings, on August 15, 23, 25 and 28, these and other contractors were discussed. In addition, Allen went to Toledo, Ohio, and to Chicago in search of contractors for Better Homes.

On August 20, 1950, Allen gave an overview of the board meetings to the general membership and showed them the deed for the eighteen lots as palpable proof that they were moving forward. He also read a letter from DeHart Hubbard, who "stressed the importance of securing our lots and seeing that water and sewage be installed." Hubbard had emphasized all along the importance of additional lots as well as land development.

DeHart Hubbard was back for the September 7 general meeting, together with his superior, Mr. Sawyer. Perhaps Sawyer's very presence hinted at the problems Better Homes was facing and was intended to reassure the membership. Obviously, a big crowd was expected, for this was the first time that the corporation's general meeting took place in the Milan Annex of Hering House. The one-story brick building attached to Hering House was added in 1945 because more space was needed for all the activities that had grown up in Hering House. The annex was named after the first African American soldier from South Bend to die in World War II.

Mr. Sawyer began by commending them all "for the rapid and wonderful progress already accomplished." He added that he himself could not transact any business on their behalf but that he would assist them in any way he could. Then followed a report on contractors. One was singled out as the most

promising. This was Max Meyer of 1717 Oak Street in Niles, Michigan, a few miles north of South Bend. He submitted a detailed but also frequently revised list of prices. On August 23, Max Meyer had offered a conventional 1,088-square-foot house without a basement for $8,000. Two days later, he had lowered the price to $7,200 without and $8,000 with basement. Then, as recorded on September 7, he priced a two-bedroom home at $6,500, and a six-room home with three rooms downstairs and three rooms upstairs at $9,000. A one-and-a-half-story home with an unfinished upstairs would cost $8,700 or, for a lower-cost version, $8,100. In addition, there were all kinds of options at extra cost depending on the size of the home: $1,000 to $1,200 for a full basement, $50 to $75 for plaster walls, 5 percent extra for brick facing, $200 for hardwood floors instead of concrete slab. Despite Meyer's vacillations, his figures corresponded to, or even beat, the average cost of housing, which was $8,100 in 1950. It went up rather steeply to $9,820 in 1951.[60]

This picture shows Private William Milan, the first African American soldier from South Bend to die in World War II. The Hering House Annex was named in his honor. *Collection of Local & Family History Services, St. Joseph County Public Library.*

DeHart Hubbard liked both Meyer's figures and that he didn't use factory-built homes. These had become popular, but they offered little variety and few choices for their customers. Hubbard also appreciated that Meyer was willing to develop the land, which meant one less major headache for the corporation. But he told the group that he needed to compare Meyer's proposal to FHA guidelines. In the meantime, he suggested that each night, six families go to Meyer's Niles office prepared with their questions. After that, a motion to use Meyer as builder was approved unanimously and a schedule set up for individual appointments with the firm.

BETTER HOMES OF SOUTH BEND

The meeting ended with Hubbard emphasizing "the dire need of members, and the fact that a restricted covenant be used in future neighborhood." Fred Coker motioned and Florence Adams seconded that Allen draw up a restricted covenant. The motion carried. A restrictive covenant is standard procedure in land development to limit certain uses of the property, such as allowing only single-family dwellings. It is intended to enhance property values. In the discriminatory housing practices of that time, however, such covenants were a means of keeping minorities out of neighborhoods. It is not clear what Hubbard meant by the dire need of members. He might have thought that a larger group would create a bigger impact or would lower prices for everyone, or he might have thought of the dire need for housing for African Americans that Better Homes could help to alleviate.

One major reason for the impasse was not getting the land improvements necessary to start building. Above all they needed sewer and water lines. Perhaps the postwar building boom can be seen as one excuse why the city, busy with many other construction proposals, was slow to move. Nola Allen, however, attributes it to a general unwillingness to have Better Homes families move into the North Elmer neighborhood. Her assessment certainly fits in with what was happening in South Bend at that time. African Americans had seen too many instances of harassment and discrimination from both private and public quarters.

Yet there may be another explanation for these particular delays. In the first three years of the 1950s, just when Better Homes needed its sewers, the city was in crisis. Up until then, South Bend had no wastewater treatment plant. Waste went through the sewers straight into the St. Joseph River. It had been thought that moving water would clear up any contamination on its own. But then the state Department of Health pushed the city to stop this environmentally hazardous practice, collect the sewage and install a wastewater treatment plant. A gigantic interceptor line had to be built to collect the sewage from the five hundred miles of the city's sewers. It was a momentous and costly undertaking that was not completed even in 2015. The city engineer must have been preoccupied with that project and might not have had the time or the resources to devote to any relatively small individual demand for sewer lines.[61]

At any rate, negotiations about sewer installation stretched over months and eventually years, and members became increasingly discouraged. Leroy Cobb remembers, "So many, even my wife, Margaret, were getting impatient. They wanted their money back and then go out to look for another place."

An American Story of Courage

Another problem that troubled the group for the remainder of 1950 was that they could not get Meyer to settle on a price for building the houses. He had changed his price list several times and given different prices to different members. So the board finally told him that he needed to fix a definite price and stick with it.

Despite these problems, Allen, supported by Hubbard, kept working on getting new families to join Better Homes and buy the additional lots for which the corporation had an option. However, suspecting opposition from various groups in South Bend, he urged everyone to solicit new members as quietly as possible. At the September 13, 1950 board meeting, he told them not to follow a suggestion he had heard that members recruit new families by making announcements in their churches. Instead, he advised, they should solicit prospective members privately and individually. The board also stipulated that after the first twenty-six lots were sold, new members had to pay $500 instead of the original $400 for each lot, no doubt accounting for the improvements already made.

However, Better Homes moved ahead in one important aspect. At the general meeting of September 29, 1950, twenty-six lots with their house numbers were assigned to all current members. This move counteracted a little the frustration with the impasse over sewers, financing and builders. Better Homes had worked out a procedure early on for how lots were to be chosen. Each member was given a number according to when the full $400 payment for the lot had been made so that he or she could choose a location in that order. Leroy Cobb had paid in early in order to obtain a corner lot. At number two, he chose his lot on the corner of North Elmer and Keller Streets. It was the first house in the 1700 block, with an address of 1702 North Elmer and across from Hagedorn's basement home. The listing in the order members paid shows the man's name, followed by the lot number and then the house number on North Elmer Street.

Wade Fuller	405	1802
Leroy Cobb	420	1702
Robert Taylor	435	1757
Clint Taylor	424	1713
Marcus Cecil	412	1734
Bland Jackson	419	1706
Gus Watkins	418	1708
Earl Thompson	417	1714

Better Homes of South Bend

John Fleming	415	1722
Arnold Allen	411	1737
Robert Allen	416	1718
Schyler Braboy	398	dropped out
Obry Chambers	404	1806
Joseph Roberson	399	dropped out
F.D. Coker	414	1726
Bozzie Williams	432	1738
Albert Warfield	433	1749
James Adams	434	1753
W.C. Bingham	428	1729
Eugene Northern	430	dropped out
Sherman Paige	441	1826
Willie Gillespie	446	1841
Robert Graham	447	dropped out
Donald Howell	442	dropped out
Walter Hubbard Jr.	439	1737
Herschel Collier	397	dropped out

Schuler Braboy, Joseph Roberson, Eugene Northern, Robert Graham, Donald Howell and Herschel Collier all dropped out. After two new families joined, in the end there were twenty-two lots spoken for on North Elmer Street. Louis Stanford and Frank Anderson were the newcomers, and they were given the last Better Homes lots in the 1800 block of North Elmer, Stanford at 1834 and Anderson at 1830. By the time Anderson joined, he had to pay $600 for his lot.

Several names on that list of house assignments have not yet been identified because neither husband nor wife served as an officer in Better Homes. But they, too, followed the pattern of northward migration, most of them arriving in South Bend in the 1940s. Three came from Tennessee. Eugene Northern and his wife, Ellen, were born in Jackson, where they got married in 1930. They came to South Bend shortly thereafter. Willie Gillespie was from Memphis and came to South Bend as a young man in 1948. Millie Fleming was from Elkton, Tennessee. Two were from Kentucky. Albert Warfield was born in Earlington in 1909 and arrived in South Bend in 1940. John Fleming came from Hopkinsville. He and his wife moved to South Bend in the 1940s. Two members were from Arkansas. Rosie was born in 1918 in Wabbaseka

and married Albert Warfield in South Bend in 1948. Bozzie Williams came to South Bend from Marked Tree, Arkansas. There were two also from Louisiana—Clint Taylor from Baton Rouge and Robert Allen from New Orleans—who both arrived in South Bend in the 1940s.

The rest were from a different state each: Lila Williams from Dover, North Carolina; Louis Stanford from West Virginia; Walter Hubbard from Leland, Mississippi; and Orbry Chambers from Cairo, Illinois. That leaves only James Adams unaccounted for, but Leroy Cobb is certain that he, too, was originally from the South. Out of the whole group, only F.D. Coker, Orbry Chambers and Louis Stanford did not work for Studebaker.

The assignment of lots and house numbers had the desired effect of cheering them on with the promise of success. And then came another piece of good news. On October 19, Allen could tell the board of directors that the FHA had formally agreed to handle the permanent mortgages. Members had to come up with a 10 percent down payment up to a total of $5,000 and ⅓ percent down on each $1,000 in excess of the first $5,000.

The valuation of the improvements was not yet definite, however. For each family, the total cost of improvements should not exceed half the cost of the lots. Allen submitted letters of petition for sewage and water. Yet deadlines and promised dates of completion passed without noticeable progress, and again there was discontent among the members. So the "deeds were passed for inspection and to dispel any rumors that definite progress was not being made by the corporation."

Allen stressed once more that cooperative building was the best means for building and explained this further at the general meeting of October 26. He laid out details of the cooperative housing credit regulation whereby the deeds were held by the corporation rather than by individuals. The value of the lots and all property would at first belong to the corporation, and the corporation would obtain money for improvements. For future owners that cost would be added to the price. Better Homes, however, would not remain a not-for-profit cooperative. At the end of the term, when the cooperative building contract was dissolved, all excess moneys were to be divided equally among the members.

In an attempt to allay fears that nothing was happening, Allen distributed copies of zoning maps. He assured them that the corporation would get financing from a local bank with a temporary loan so that construction could begin. The corporation now would need a capital of $3,315 rather than the $2,000 Allen had estimated at the outset. He also told them that the water company had reduced its installation fee from $160 per lot to $50 to be paid in five yearly installments.[62]

Better Homes of South Bend

At the last board meeting of 1950 on December 27, members were informed that George Sands had granted the extension of the option of lots, presumably on Olive Street, until May 20, 1951, and that Louis Stanford was accepted into the corporation.

Max Meyer remained the chosen contractor, and a summary of the project and its costs was outlined in the spring of 1951:

Loan	$221,000
Construction	$208,000
Balance	$13,000
Mortgage Fee	$1,105
FHA Expenses	$663
Inspection Fee	$1,105
Financing	$2,210
TOTAL cost of fees	$5,083

The total cost of fees to the corporation amounted to $195.00 for each family. To this must be added the sewer cost, estimated at $7,150.00, and paving, at $8,450.00. The monthly loan payment for each family was estimated at $52.75.

Throughout 1950, board members, often accompanied by their attorney, made trips to Indianapolis to get additional help, advice and encouragement from Mr. Peters, Indiana director of the FHA. It was clear to them that they could not succeed unless they recruited as much outside help as possible. Luckily, the corporation had the means to refund traveling costs as well as pay for lost work hours. Marcus Cecil was reimbursed fourteen dollars and Robert Allen eighteen dollars for a day's work at Studebaker, and Lureatha Allen was reimbursed seven dollars for her day.

At the February 12, 1951 general meeting, Chester Allen was on record "that when the loan is granted, it will be in terms of the 41 lots instead of 26," which showed that he still was hoping for a much larger development. He also suggested that Fred Coker, chairman of the Construction and Development Committee, contact the Gas Company, Northern Indiana Public Service, to make an application for at least fifteen families for gas-heated homes. Better Homes had been told that gas would be available for no more than fifteen houses; the remaining seven would have to make do with propane for a year until a gas line could be installed. One wonders about the reason for such

a restriction, but there was a systemic design problem with the city's gas lines, a problem that still existed in the year 2000. The network in that area may well have been at its limit and could provide only a limited number of additional houses until a stronger node was installed.[63] Nevertheless, it is not surprising that some members thought of this as additional harassment. At the end of the meeting, Cleo Taylor was appointed secretary of Better Homes, replacing Louise Taylor, who continued to keep the minutes of the board meetings since she was a member there.

On March 10, 1951, Better Homes held another important meeting with Hubbard in attendance. He first told them reassuringly that he was "most favorably impressed by our progress." Then he made the following statement: "We would go down in History as the first corporation in Indiana to sponsor such a successful adventure." With these words he summed up the historic significance of the Better Homes enterprise not only for its members but also for African Americans in the city and perhaps the state altogether. His words could well stand as a motto for Better Homes. And they could not have come at a better time to give hope and encouragement.

Perhaps in a further effort to show that progress was being made, Hubbard advised that the treasurer work with the secretary to put together a typed financial statement. A three-member auditing committee was established with Leroy Cobb, young as he was, as chairman and Arnold Allen and Ruth Chambers as members. The treasurer reported that the Construction and Development Fund had $2,074.68 and the Miscellaneous Fund was down to $18.57. After a long, difficult but also inspiring meeting, Lureatha refreshed all participants with ice-cold Coca Colas.

The city continued to be a roadblock since it was slow to provide the improvements necessary for Better Homes to start building. "We had to petition the city for everything," remembers Leroy Cobb. In late March 1951, Chester Allen wrote a firm letter to the city engineer "stating that Better Homes of South Bend, Inc. owned the said lots, and contemplate building 26 homes with construction according to the Barrett Law plan, and that at a future date they plan to purchase more lots from the county." The Barrett Law provides a way to pay for a municipality's special assessments, such as paved streets, sidewalks and sewers. Better Homes would follow standard procedure and petition for the Barrett Law. If accepted, the city would issue a bond with which to pay the contractors who built the sewers and paved the street. Better Homes, in turn, had to commit to paying for its part of the project in specified installments. To speed this complicated process along, Better Homes hired civil engineer

BETTER HOMES OF SOUTH BEND

Wilbur H. Gartner of Gartner and Associates, who was to present their case to the city.

In his letter to the city engineer, Allen tried to convey both the group's impatience with the slow process and the unalterable fact that its members were definitely going to build their houses. He indicated that Better Homes was there to stay and would even grow in the future. Working through the Barrett Law plan, Better Homes was adhering to normal procedure and now expected the city to do likewise. The city engineer promised that in about one month, by the end of April 1951, he would have the sewer and paving in progress. This estimate turned out to be way off the mark. In fact, the sewer took until May 1952 to be completed, and paving did not happen until eight years later. One has to wonder whether other, perhaps more prosperous developments got their paving faster?

At a meeting in June 1951, DeHart Hubbard did his best to calm members who felt harassed from all sides. He must have thought that there was a threat of the whole enterprise falling apart, for he not only strongly advised patience but also "urged the necessity of holding the corporation together." He explained that financing was a nationwide and not just an African American problem since lending institutions everywhere were practically depleted. This was true locally as well. The *South Bend Tribune* reported a 41 percent drop in building construction and attributed the decline in large part to tighter financing.[64] Nevertheless, African Americans faced the heavy additional burden of discrimination in lending.

Most of 1951 demanded more patience and perseverance in the face of complications that kept cropping up. Better Homes needed to find another architect since the architect associated with Meyer did not work out for some unexplained reason. The group was lucky to settle on South Bend architect Vincent F. Fagan. He had participated in a public housing project in 1949, was well aware of all the difficulties Better Homes was facing and committed to make its project work. He told the group that "he was interested in our effort to build homes and would do all he could to help solve the housing problem." Fagan even reduced his usual fee to draw up detailed plans of individual homes to just fifty dollars for each family. Everyone was relieved to have found an architect like Fagan so ready to help.

With that settled, Allen and the Better Homes leadership focused once again on the additional lots on Olive Street. In May and June 1951, the option they already had placed on these lots was under constant discussion. But at this point, they had not come up with any families willing to buy the lots. Then the FHA informed the corporation that if it used the Olive

Street option, it could build on those lots but only as a separate corporation. Another delegation was sent to Indianapolis to discuss this further with the FHA. Amid this confusion, a few details about the Elmer Street houses at least began to take shape. The total of the mortgages to be insured by the FHA amounted to $245,700.00 and fall taxes for the lots came to $53.90.

Thus, 1951 passed in an arduous process of petitions and drawn-out negotiations about improvements and financing. Members feared that each step forward was countermanded by qualifications and prevarications and that they would never see their houses built.

8

Home

We would go down in History as the first corporation in Indiana to sponsor such a successful adventure.
—*DeHart Hubbard, March 10, 1951*

In November 1951, Lureatha Allen at last could report to Better Homes that permanent financing had been secured under 203, the HUD Basic Home Mortgage Loan 203 (b). There were no further details about this bombshell news. It meant that the corporation had secured a temporary loan for the project. This was an important step that would allow the group to start construction. After that, each family had to obtain their own mortgage loan.

Next, however, Lureatha Allen added something that could still hold things up: "We had to handle our own sewer contract." Mr. Gartner then stepped up to explain the steps necessary to secure the Barrett Law, which he hoped would happen early the following year. He also told the group that the sewer costs for each of them would amount roughly to $210 for each lot.

In the new year, Better Homes needed to find banks to provide individual loans for its twenty-two families. Therefore, in early 1952, a small delegation accompanied DeHart Hubbard as he met with South Bend bank executives, including First Bank, National Bank, Tower Bank and South Bend Federal Savings and Loan. Most of them in this delegation were apprehensive, for they had at least heard of bad experiences with bankers denying loans to African Americans, especially for homes outside the traditional black neighborhoods. Leroy Cobb was part of that group. "Here I am, just a bit

over twenty years old, sitting in one of those fancy board rooms and facing all these white men in their suits." DeHart Hubbard did not appear to be in the least intimidated. On the contrary, he reminded the executives that the federal government supported their banks with its FDIC insurance. He added something like, "We understand that everyone has to have good credit. But we already own the land, and it is suitable for building; so just check their credit." These words were similar in tone to what Chester Allen had told the city engineer, that Better Homes had proceeded correctly and expected others to do the same and that the organization was here to stay. Thinking back on that long-ago meeting with the bankers, Leroy Cobb said, "What I was really proud of was that here was a black man standing up to white executives and telling them that Better Homes wants to have a fair shake. It inspired me."

The other major issue at the beginning of 1952 was that Better Homes' contractor, Max Meyer, failed to make any progress. He tried to explain the causes for the delay but then added that he needed a down payment of 15 percent of the entire cost. It's hard to imagine that he got a favorable reaction, and the next time he appeared before Better Homes, he was more positive, telling the group members that they were definitely at the point where they were sure of getting their homes. They then settled on home specifications. The houses were all to be one-story frame construction on concrete slab without basement, except for Gus Watkin's home at 1708 North Elmer, which included a basement. Brenda Wright remembers her mother saying that if only she had known about the advantages of basements, she certainly would have gotten one as well. But coming from the South, she was not familiar with them. Since there was an embankment on both sides of the street, steps were to lead up to each house. The floorplan for the five rooms and one bathroom was the same for all houses. The only variation was caused by where the house sat on the lot, which determined where the entrance door was located.

At a general meeting in early March 1952, Better Homes took a big step forward. The president announced that financing for all families would be handled by four local banks. However, there was yet one more hoop to jump through. "We are to submit three more applications to the FHA to serve as guinea pigs, Warfield, Fuller, and Cobb were chosen." Cobb was part of that guinea pig group because his credit was particularly solid. He was young and had some savings, no debt and four years seniority at Studebaker.

The next welcome piece of news came at a general meeting a few weeks later, on March 24, at the Milan Annex. Gartner told the group that he had

presented their sewer case on March 12, 1952, in city hall. It was accepted. And on April 25, Lureatha Allen told everyone that the sewer was almost completed and that they would be informed when they had to pay the full amount for its installation.

So construction could finally begin. Just at the point when construction could finally begin, Chester Allen informed Better Homes members that he had had to change contractors. Unfortunately, the reasons were not spelled out. Leroy Cobb said that specifications of several contractors did not meet FHA standards and that Meyer also wouldn't abide by the code. The Better Homes leadership must have long been dissatisfied with the Niles contractor, for they had been looking for a replacement. They found one in Hubert Woodcock, who was present at the end of the April 25 meeting to talk about preliminary changes in house plans. Woodcock, however, could not handle all twenty-two homes. So John Skiles, another private contractor, was brought in. Between them, they built all the Better Homes houses. Frank Leahy's lumber company on William Street was chosen to provide the lumber for the frames.

On June 30, 1952, it was time for an election of officers of Better Homes. The board decided, however, that since it was in the final stages of negotiations, it would be wiser to hold off, as the secretary recorded, "until things started going." This is another hint that, even at this late point, members weren't entirely sure whether things would start going in earnest. It must have been around the same time in the summer of 1952 that a bit of serendipity, combined with Nola Allen's initiative, helped Better Homes to the completion of its mission. Nathan Levy, a South Bend attorney and graduate of the University of Michigan law school, happened to visit his alma mater. Nola Allen, a law student there, used the opportunity to tell him about the difficulties Better Homes was having that neither Allen nor Hubbard seemed able to resolve. Levy, known for his enduring commitment to social justice, promised to do what he could to help the corporation. A partner in the law firm of Crumpacker, May, Levy and Searer, he was a prominent attorney with a strong record of civic leadership. Together with his wife, Norma, he had organized civic action groups and received many awards for his contributions. Stanley Ladd, chairman of the United Way's labor committee, was reported to have said of the couple: "They have given unstintingly of their time and efforts to help people, regardless of race, color, or creed."[65] For the purposes of Better Homes, Levy had the added advantage of inside knowledge of how the city operated. Twice in the 1940s, he had served as South Bend's city attorney. Levy was born in South Bend on October 25, 1909, and died there at the age of sixty-

Better Homes of South Bend

This view of the 1700 block of North Elmer Street in 2015 shows (from left) the former homes of Earl and Viro Thompson, Gus and Josie Watkins and Bland and Rosa Jackson. *Peter Ringenberg, photographer.*

four. He is still remembered both for his humanitarian commitment and his endearing personality.

It is not clear just how Nathan Levy helped Better Homes, but he did so behind the scenes and in collaboration with Chester Allen. Most likely, it was a combination of his experience as city attorney and his prominence as a respected civic leader, for soon things were really getting going. The Better Homes families were on their way to having their homes. On September 10, 1952, twenty people paid $2.75 each for a total of $54.10 for recording their deeds. They must have all gladly paid that small amount so that they could actually hold those precious deeds for which they had waited for more than two years. In the late fall of 1952, Bland Jackson was the first to move into his brand-new house, located at 1706 North Elmer Street, right next to where the Cobbs were to live. However, there were no celebrations at that time because no one else was close to moving in.

One question individual families still had to address was whether they wanted to add a garage. Frank Leahy of the lumber company explained that garages had to be entered under a separate loan at a cost of $940. This had one advantage with financing their house loans. Mortgage payments

were counted from the moment construction began and not from the time people moved into their houses, but if they added on a garage and got a construction loan for it, then part of the loan could be used for those early payments. Nevertheless, only Bingham and Watkins took advantage of this. In later years, some others, including Leroy Cobb, added a garage to the back of their houses.

DeHart Hubbard came to town again on September 29, 1952, to impress on the group how important it was that they increase their membership with lots in the adjacent areas. Both Hubbard and Allen were so insistent about this because they were trying to address the tremendous need of good and affordable housing for African Americans.

Added pressure on housing came from the tear down of the temporary defense homes. That process began shortly after the Better Homes families had moved into their new homes. They all followed closely the stories reported in the *South Bend Tribune* about tearing down the defense homes, including the ones on Prairie Avenue where they had lived. On September 10, 1953, the *South Bend Tribune* reported: "Six hundred and fifty South Bend families occupying four World War II emergency housing projects face the prospect of ceasing to be tenants of the federal government by June 30."

So Allen and Hubbard were looking ahead and hoped to meet these growing needs, but they couldn't find additional members. The reasons might well have been financial. Or perhaps people who witnessed the long struggle of Better Homes were afraid of the drawn-out process and of relocating to an area that had not been open to African Americans where their children would have to attend all-white schools. The original group was a close-knit community, willing to stick together and face any storms. The fact that they didn't succeed in recruiting additional members highlights once again the difficulty of their enterprise as well as the powerful connection and intelligent cooperation of the Better Homes family.

In a meeting in late May 1953, Better Homes paid Allen $1,300 as part payment for his services. After all the houses were built, he also was presented with several vacant North Elmer lots as final payment. These may well have been the four lots that were not built on because the members had withdrawn from Better Homes. The chief reason for the May meeting, however, was the election of new officers. For that purpose, the president vacated her chair, and Chester Allen acted as moderator. The nominating committee suggested the continuation of the current officers: Lureatha Allen for president, Earl Thompson for vice-president, Cleo Taylor for secretary and Bland Jackson for treasurer. Nominations from the floor added other names: for

president Earl Thompson, for vice-president Louis Stanford and Lureatha Allen, for secretary Leroy Cobb, for treasurer Lureatha Allen. When both Bland Jackson and Lureatha Allen declined the treasurer's position, Orbry Chambers was nominated. After nominations were closed, the group voted and elected an entirely new group of officers. They simplified the process by passing a motion for which "the secretary [would] be empowered to cast one vote unanimous." In this way, Earl Thompson was elected president for 1953, Louis Stanford vice-president, Leroy Cobb secretary and Orbry Chambers treasurer. Cobb does not think that this was in any way a political move to unseat the old guard or a battle between parties. Everyone agreed to the change in leadership, and it was all done amicably.

After the election of new officers, Better Homes recorded a vote of thanks to the outgoing officers "for the fine work done." James Adams offered an amendment that "a party be given as a token." But the amendment was withdrawn. Instead, they decided on a celebratory picnic with a tentative date of June 12, 1953, and appointed Louis Stanford chair of a committee to make the arrangements. But when the time came, several homes still were under construction, including that of their former president, Lureatha Allen, who had opted to have her house built last. So the picnic was postponed until the following summer.

Leroy and Margaret Cobb moved into 1702 North Elmer Street on Saturday, November 1, 1953, over three years after that first secret meeting of Better Homes. The date is etched in Leroy's mind. "I was elated." They now had plenty of space for their growing family. Their third child was to be born in a couple months. And here Leroy was, only twenty-three years old, and he owned his own brand-new home in a nice neighborhood. He often thought of others in their group who, although much older, had never had a home of their own before this. His grandmother on his mother's side often told him: "You don't know how fortunate you are. I've never owned a home." Margaret and Leroy did know, however, that they were fortunate and thanked God for this bounty every Sunday in church.

The Cobbs' house, which included an enclosed porch, cost $8,250. The mortgage came to $54 a month. They had obtained a twenty-year loan from the South Bend Federal Savings and Loan, which Leroy is proud to have paid off in seventeen. Leroy still has the deed to his former property, a yellowed and much folded document. He received it on August 9, 1952, but it was not recorded until construction of his house began on April 15, 1953. The document was signed by the president of Better Homes Lureatha Allen and the secretary Cleopatra Taylor. Although restrictive covenants were not

An American Story of Courage

Leroy Cobb has kept the warranty deed of his house at 1702 North Elmer Street.
Courtesy of Leroy Cobb.

mentioned again after the group had decided to include them and asked Allen to draw them up, Cobb's deed shows six such covenants, to remain in force until January 1, 1972. All were designed to keep the Better Homes blocks a well-maintained residential neighborhood. Covenants included a lawn space in front of the house of at least twenty-five feet in width; detached garages in the back of the house only and not to be used for human habitation; no building on the lot to be used for commercial, industrial or illegal purposes; and no poultry, hogs, horses or cattle to be housed on the premises.

Leroy Cobb can be proud of his work with Better Homes. Although by far the youngest member, he played an active role in the organization. He served on committees, even as chair, and he was chosen for special delegations, such as the one to the bank executives. He never lost faith in their venture or their leaders but stood by them staunchly through all setbacks. He also picked up every bit of insight and knowledge he could garner. It was all new to him. He learned about the FHA and FDIC insurance, about financing, committee procedures and dealing with officials. It opened his eyes to the wider world, and he put his newfound knowledge to good use in later life. He became quite bold in his own financial dealings. As soon as an opportunity presented itself, he invested in real estate and did well with that. At one point, he owned eight houses. But he paid cash for all of them and never took on another loan. He also learned a polite, diplomatic and firm way of dealing with financial executives and city officials. And ever since meeting Hubbard, he made it a point of always appearing well dressed. As a result of all this, his family was not only financially secure but also well off, with money to spend on international travel and vacations. Today, Leroy Cobb is committed to teaching his many grandchildren the lessons he learned with Better Homes. He takes them to meetings with financial officers and impresses on them, as Reverend Frazier did so many years ago, the crucial importance of regular saving. Beyond that, he stresses the guiding principles of courage, faith and family. As he said on the occasion of his fiftieth wedding anniversary: "Our dreams and goals have always brought us together and made us stronger. You have to have faith, courage, and determination to succeed."[66]

Homeownership and participation in a close-knit community improved the lives of all Better Homes families, including, as they had hoped, the lives of their children. Better Homes bears out research that shows that the move from renter to homeowner creates a significant change in attitude and general well-being. "The feeling of powerlessness is significantly

reduced…Although not conclusively demonstrated, the change in tenure results in a more frequent participation in community affairs and greater satisfaction with one's neighborhood."[67]

As planned, the group celebrated its achievement in a picnic in August 1954. For location, they chose an as yet empty lot in the 1700 block of North Elmer, probably one of the lots given to Chester Allen. Every family contributed to the event: mothers baked cakes and pies and prepared potato salads and spaghetti, and the men barbecued chicken and ribs on their grills. Allen was present as well, with his wife, Elizabeth. Everyone had a chance to thank him for his support over the previous three years. It also was the first opportunity for most of them to be introduced to Elizabeth Allen. They had heard and read about her work for African Americans in the community, but this was their first time to meet the fair-skinned lawyer-activist who was becoming quite famous in her turn. In the year of the picnic, Elizabeth Fletcher Allen was the first woman to sit as judge protem on the St. Joseph County Superior Court, and she filled the same position again the following year.

Cobb's face lights up with a broad smile at the memory of that celebration: "We were just all so happy. We talked among ourselves that it was a long

With this picnic, Better Homes celebrated its success in the summer of 1954. Elizabeth Allen is in the third row to the far right; Lureatha Allen is in the same row, eighth from right; and Chester Allen, wearing glasses, is standing in middle-right of the back row. *Courtesy of Leroy Cobb.*

struggle and how we started out." Brenda Wright, daughter of Lila and Bozzie Williams, remembers her parents rejoicing that their mortgage payment was less than the rent they had paid on Prairie Avenue. Looking at the smiling faces in the picture, one can sense the pride and happiness of that large group of men, women and children.

9

THE ELMER STREET COMMUNITY

On Elmer Street, I had many dads.
—*Michael Jackson, 2014*

Even the euphoria of the picnic paled against what happened after the twenty-two families had settled into their new homes. They had made the long journey from the South in large part to rescue their children from Jim Crow, and once in South Bend, they did all they could to find a pleasant and safe place for them to grow up. They did not want to raise their children in the segregated and unhealthy environment of factories and slums, which posed a danger to their bodies, souls and very lives. But probably no one could have foreseen the tremendous impact of what they accomplished, a power for good not only for themselves and their children but also for at least a generation beyond. Brenda Wright, daughter of Bozzie and Lila Williams, summed it up best when she said: "We should be forever indebted to our parents that they made this move. It made a difference for all our futures."

All the "children," of Better Homes, many themselves retired by now, feel the same way about their parents. Brenda's brother, Keith, added: "It was a wonderful neighborhood to grow up in." They had nice new homes and a picture book American neighborhood. "We had hedges between our homes, and flowers in the yard. On Saturdays you could hear the lawnmowers in the yards," remembered Michael Jackson. Nancy Fuller agreed: "We were

Better Homes of South Bend

Two friends and neighbors, Beverly Cobb (left) and Blandette Jackson (right), stand on Elmer Street in the 1960s. The little girl in the middle is not known. *Courtesy of Beverly Reynolds.*

proud of where we lived." This brought everyone to remember what others thought of their neighborhood. "When you lived on Elmer, they all thought you were rich." And in a sense, they were, not rich as in amassing a fortune, but rich in community and quality of life.

For it was more than a physically attractive place; it was a community. In addition to a loving two-parent home, the children also had a larger community to rely on that was just like family. "We were in and out of each other's houses all the time," said Michael Jackson. All the mothers and fathers looked out for not only their own but also everyone else's children. "You couldn't get away with anything," laughed Michael Jackson. Leroy Cobb still often will say about one or another of the boys: "He was like a son

An American Story of Courage

Valerie Cobb and Blandette Jackson enjoy the newly paved Elmer Street, 1960. *Courtesy of Leroy Cobb.*

to me." And that is exactly how Michael Jackson experienced it: "On Elmer Street, I had many dads." Rosie Warfield put it this way: "It was a loving and caring upbringing. I wouldn't have traded my childhood for anything. We were blessed to grow up as we did."

All the Better Homes children still love to talk about their childhood, buying broken cookies at Kresge's, snitching cherries from a neighborhood tree or running away from an always angry and often drunk Mr. Hagedorn in his basement house. When Kathy Bingham mentioned the neighborhood dog, Boots, everyone immediately thought of the time when Boots stole a

Better Homes of South Bend

This shows the Bingham family at home in 1959. *From left to right*: William, Kathy, Bonita and Katherine Bingham. *Courtesy of Kathy Bingham.*

chicken from Fred Coker's barbecue pitch. They fondly remember summer block parties, where everyone contributed food and pop. In August, North Elmer Street even organized a parade with a King and Queen. Dads constructed wagons for the occasion, and the babies were pulled along in them by the older kids. Moms sewed brightly colored sashes for the royal couple. The girls, big and small, proudly marched around their neighborhood twirling batons.

Most of them started out at Marquette Elementary School, where they were the first African American children to attend and often the only African Americans in their class. Brenda Wright remembered that just as they were all starting out at Marquette, the principal, Mrs. Alexander, organized a

An American Story of Courage

Elmer Street held an annual parade with a king and queen. Here are the baton twirlers in the parade of August 1962. *Courtesy of Vicki Belcher and Brenda Wright.*

meeting of white and black families to explain the new situation and make sure that there would be no problems. And Brenda said there were none. She regularly played with her white classmates and was invited to their birthday parties. Frank Anderson's son, Frank, agreed, "Everything was good for me at school. We didn't feel mistreated." He was a sought-after athlete who had many white friends. "Even my first girlfriends were white." He learned about discrimination and prejudice only as an adult, and he now looks back nostalgically to his happy childhood. "I wish I could go back to those times."

The other boys played sports as well, and Michael Jackson credits their coach, Mr. Sloan, for "taking good care of us in school." And as soon as school was out, most of them got on their bikes to play baseball and

basketball in the parks. But there was one thing, Michael Jackson said, "that still hits home even today." The Elmer Street boys were prevented from joining the little league. "They changed the borders of the little league district to have them stop just two blocks before Elmer Street so that we weren't eligible to participate. And there were no other little league places for us to play." Instead, they played in the South Bend Park Leagues, and while they enjoyed the games, Michael still feels angry about that little league maneuver to exclude them.

Otherwise, most of them did not experience any major acts of discrimination at school, although they were aware, as Michael Jackson said, "that as a black you were always being looked at in school." So their mothers took enormous care that their clothes were always clean and freshly pressed, their hair washed and combed neatly and their hands clean.

Only Cobb's eldest son, Leroy Jr., painted a different picture. Speaking of his years at Marquette, he said outright: "I hated school. There was so much racism." One experience in particular is indelibly etched in his mind. When he and his friend Leroy Thompson were patrol boys at the school, they became suspects after a paperboy had been robbed. Leroy Jr. still remembers vividly how overwhelmed he felt when he had to face detectives who had come to school. Both their mothers were present at the hearing. They were angry because they felt that their children were suspected for no other reason than that they were African American. Actually, Leroy Jr.'s father had had a similar experience years earlier at Central High School when all African Americans were called to the principal's office because a white girl supposedly had been raped. Leroy himself was the only one allowed to leave right away. He was obviously well liked by both students and faculty. His yearbook entry at graduation called him "Everybody's pal."

Leroy Thompson, son of Sarah and James Carter, also will never forget that terrifying incident of being accused of robbery. In his case, two policemen pulled him out of class and took him, all by himself, to the principal's office, where he had to face two plainclothes detectives. "I was frightened to death," said Leroy, especially when one of the detectives moved close to where Leroy stood and towered over him in a threatening posture. But then his teacher Mary Burger burst into the room, telling the detectives that Leroy was one of her students and a boy of good character. Then she turned to the scared boy and told him to go back to his class. Leroy Thompson never has forgotten that act of kindness, just as he has not forgotten the terror of that day.

After school, Leroy Jr. was the only one in their group who preferred to leave his neighborhood to go to J.D. Oliver Park on South Laurel Street

across from his grandmother's home. He liked to play with the large number of African American children there. Keith Bingham did not go with him. "No way would I prefer Oliver Park over my neighborhood. There was a lot of fighting in that park."

Keith, who was two grades ahead of Leroy, was the only African American in his class as well. He was aware that there was some level of bigotry at school, especially in those early years, and even among some of the teachers, all of whom were white, but it was scattered, he said. Some of the white students had never been with any African Americans and clearly were prejudiced. But others were open-minded, and he made friends with them. "I'm still in touch with white classmates from Marquette." The school drew from many working-class families, but closer to Portage Avenue, there were large homes with middle- and upper-middle-class families, several of them Jewish. They tended to be more liberal.

Both Keith Bingham and Brenda Wright mentioned that they were somewhat isolated on North Elmer Street. Keith characterized it this way: "It was like a little island among all the white neighbors." Brenda added that the only time they were part of the larger African American community was at church. But neither felt this as a disadvantage. In fact, Keith thinks that interacting with white students at Marquette had its benefits. It made him comfortable with a diverse group, and to this day, "I am a firm believer in integrated educational settings."

After finishing at Marquette, some attended Muessel School, which was a mile and a half from their homes but had many more African American students. The older students went even further to Central High School in downtown South Bend. Only the youngest ones could go later to the nearby newly built LaSalle High School, where the first student from North Elmer graduated in 1967 after one year at LaSalle and the first four-year class graduated in 1969.

The parents had instilled into their children that education was of prime importance for them to succeed in a white man's world. Brenda will never forget one of her grandmother's favorite sayings: "Be sure to get an education. That is the only thing the white man can't take away from you." Most parents took on extra jobs to save for a college education for their children. Such stress on education was typical of southern migrants altogether. Gladys Muhammad's father worked every weekend on a dump truck so that all his seventeen children could receive a post–high school education. The children of Better Homes transferred the same message of the crucial importance of education to their own children, so they, in turn, have reared a generation of successful professionals.

BETTER HOMES OF SOUTH BEND

Perhaps no one in that first generation of children represents the success in education better than its eldest member. Nola Allen, daughter of Lureatha and Arnold Allen, was already a lawyer in Indianapolis when her parents moved to Elmer Street. She went through school well ahead of the rest. She fondly remembers the encouragement a white teacher, Ernest Harvey, gave her at Oliver Elementary School near her Prairie Avenue home. When she confided in him that she wanted to become a lawyer, he responded: "Nola, you can be anything you want to be."

At Central High School, Nola took advantage of the many afterschool activities offered there. She was the first African American to join the Barnstormers, the theater group under the locally famous director James Lewis Casaday, and the first to be in the Glee Club and the orchestra, where she learned to play the bass violin. She also was an alternate on the Varsity debating team. The only racial hurdle she could not surmount was swimming, where African Americans were not allowed. In the spring of 1949, Nola caused a stir in another way when she managed to graduate early. Her move knocked Ann Rosenberg out of the salutatorian position, which Nola still remembers with glee. The *Interlude*, the Central High School Yearbook of 1949, listed her as the "Laughing Lawyer," although in her graduation picture, Nola looks at the camera without even a smile. But she does somehow look distinguished, older than her barely sixteen years, with her even features, her intelligent eyes and her hair combed back from her face. Referring to her youth, the yearbook also said about her: "Big things come in small packages."

After this auspicious start, Nola was accepted at the University of Michigan in a fast track. She even won a partial scholarship from Studebaker since both her parents had worked there and her grades were excellent. She received her bachelor's degree in 1952, completed her law degree in 1954 and passed her bar exam that fall. Nola Allen practiced law for nineteen years, and after a PhD in government from the University of Notre Dame, she ended her career as a professor of political science and criminal justice at the University of South Alabama. In her retirement, she taught part-time at the University of South Florida.

It was not only Nola, however, who succeeded as a highly educated professional. Thirteen children in this generation earned college degrees and went on to successful careers. Louis and Daisy Stanford's daughter, Judy, also has a PhD, but no one knows what became of her. Wade Fuller Jr. is a retired New York City school principal who now resides in the borough of Queens. Brenda Wright ended her career as school principal and head of special

education in New Haven, Connecticut. While her brother, Stanley, did not finish his degree at Indiana State University, he studied there for three years. After that he worked as a substitute teacher and school custodian in South Bend. Michael Jackson retired from teaching at Clay Middle and High School in South Bend, and Kathy Bingham also is a retired South Bend teacher and school counselor. Her brother, Keith, is a librarian at Cheney University of Pennsylvania. Rosie Warfield first worked as a nurse and later became a teacher as well. Nancy Fuller still works in public housing in Gary, Indiana. Michael Jackson's brother, Gregory, is a dentist, and his sister, Blandette, worked for IBM. Unfortunately, she died of breast cancer when she was only in her forties. Leroy Thompson became a minister. Although his family did not belong to Better Homes, they became part of the community when they bought an already existing house at 1727 North Elmer Street. The others in the group who did not go to college all finished high school and got solid jobs at the telephone company, the gas company and the post office.

Hard work was the other chief lesson the Better Homes children absorbed from their parents. They all were witnesses to their parents' daily hard labor. Most of the fathers had two, sometimes even three, jobs: their full-time job at Studebaker and part-time jobs as janitors or office cleaners. To supplement the family's income, many of their mothers worked in addition to looking after their children and the house. Ruth Chambers worked at the telephone company like her husband. Lureatha was a nurse's aide until retirement. As soon as her children were old enough, Margaret Cobb was an assembler at Toro Wheelhorse. Geraldine Coker worked as a cleaner for the post office. Sarah Carter was a housekeeper in a white woman's home that her children were never allowed to enter. At one time, the lady accused Sarah of stealing. This turned out to be a blessing in disguise because it motivated Sarah to learn a skill. She became a keypuncher at Memorial Hospital. Rosie Miller Warfield summed up all their experiences: "Our parents were hard workers, and that work ethic continued with us."

The couples worked so hard because they were determined to get ahead, and they wanted to save money for their children's education. But they also had to deal with increasing layoffs at Studebaker. Although the factory did not close until 1963, its sales kept dropping for at least ten years before that, during which time workers were laid off more and more frequently. By 1960, Studebaker sales were "at most 1½ to 2 percent of the car market," said Andrew Beckman, archivist at the Studebaker National Museum. Leroy Cobb was first laid off in March 1953, just over three months after the family had moved into their new home and two months after the birth of their third

BETTER HOMES OF SOUTH BEND

Studebaker Building 84, the body plant where the cars were finished, was one of the best places to work for African Americans. *Studebaker National Museum Archives.*

child. He was out of work for months. It was only in the fall of 1953 when, with the help of Orbry Chambers, he got a job with the telephone company. At that time, African Americans could work only as janitors or car washers, and that's how Leroy started, changing tires, doing grease and oil changes as a mechanic's helper. Whenever he could, he brought the used oil home to keep at bay the dust on their gravel road so that everyone could open their windows without getting their houses dirty.

Cobb made much less at the telephone company than at Studebaker, only fifty-four dollars a week, and supplemented his salary by working two additional cleaning jobs, one early in the morning and one late at night. He had no car, so he had to make that long walk to downtown and back twice a day, often coming home after 1:00 a.m. And when Studebaker rehired on January 1, 1955, Leroy jumped at the opportunity, even though it meant working two full-time jobs. He was at Studebaker from 7:00 a.m. to 3:00 p.m. and at the Telephone Company from 4:00 p.m. to midnight, after which he had to make the long trek home. "You got your health and your strength. I didn't complain." He was diligent and reliable and moved up from the Studebaker foundry to the machine shop, the pressroom and then to what he called the

"Final Line," or the body plant where the Studebaker bodies were assembled. He worked on the fifth floor installing ashtrays into cars.

On Sundays after church, they all relaxed together, often congregating around one another's barbecue pits, for most fathers had built one in their backyards. The children listened to the adults telling stories about growing up in the South, how they had to pick cotton until their hands were raw, how they walked miles to get to a black school while white schools were nearby and a school bus with white kids passed them on their way. They heard Bland Jackson voice one of his favorite sayings about his home state: "Mississippi is a great state to be away from." Nancy Fuller remembered hearing that her father had to run away from Indianola, Mississippi, but she never knew why. Rosie Warfield liked the stories about her grandparents on her mother's side. Her grandfather was white, illiterate and the owner of large cotton and soybean fields. Her grandmother Alice Johnson was African American and a woman to take command. She had a bachelor of arts in home economics and was the one to organize the affairs of the man she lived with. The two never could get married since marriage between a black and a white person was illegal—including in the state of Indiana until 1963. They nevertheless spent their lives together and had many children. Rosie remembers how everyone respected, and perhaps was a bit in awe of, the redoubtable Alice Johnson, who drove her own car and owned a mink coat. Other than such stories, however, the South was present to the younger generation only through some of the food their mothers cooked: the collard greens, chitlins and beans and rice. Some families occasionally made summer trips to the South, but they stayed close to their families; none of the children was left with a real impression of what life there was like.

There is at least one other striking fact about the children of Better Homes. A considerable number of them still either live in or own their childhood homes. After her parents' death, Kathy Bingham moved back into the house at 1729 North Elmer Street where she grew up. Neither Nancy nor her brother, Wade Fuller, has wanted to give up their childhood home. Since both of them live out of town, they rent it out. Michael Jackson lives in Granger, north of South Bend, but still owns the family home at 1706 North Elmer. Across the street from Cobb's former house is one of Leroy Cobb's daughters, Beverly. She occupies one of the houses her father had moved to North Elmer back in the 1960s. Stanley Williams's son lives in the house on North Elmer where his father grew up. In addition, original member Frank Anderson still occupies his home at 1830 North Elmer, and Louis Stanford stayed in his house until his death in 1997. Now his son lives there.

Better Homes of South Bend

Better Homes did not help only its own members; it created a ripple effect as more African Americans joined the thriving neighborhood. Gradually, the empty lots in the 1700 and 1800 block of North Elmer filled with new homes, and others moved onto adjoining streets. Thanks to Better Homes, the neighborhood had become a desirable place to live and attracted educated middle-class African Americans. The area had more than its share of school principals. Algie and Sarah Oldham moved to 1758 North Elmer in 1958. Mr. Oldham was Riley High School's first black principal. Mrs. Hattie Myers moved to 1825 North Elmer. Her son, Edward Myers, became the first African American school principal at Linden Elementary School in 1959. Joe and Della Luton relocated to Huey Street, one street east of Elmer, in the late 1950s. Joe Luton, who had been the Cobbs' neighbor with his parents on South Laurel Street, became the second African American school principal at Linden School. There was no friction with the few remaining white neighbors, but there was also little interaction. The Better Homes children would occasionally play with the Hagedorn grandchildren, but the adults did not socialize together.

By 1960, nine vacant lots in the 1700 block were built up and the new homes inhabited by African American families. Except for Hagedorn in his basement house, the only other white family to remain was that of Arthur Daniels, who had bought his house at 1721 from Clinton Carson. Development in the 1800 block was slower. Only two new residents joined the Better Homes group, William Wilson at 1825, South Bend's first black fireman, and Albert Lindsey at 1841. Clotiel Johnson remained the only white person on that block at 1838. By the end of the 1960s, however, the 1800 block also was filling up with nine more houses, all of them for black families. Better Homes had found "a nice place to live" not only for its members but also for everyone who joined them in their neighborhood.

10

Yesterday's Lesson, Today's Challenges

How did we get from Better Homes of South Bend to where we are now?
—Regina Williams-Preston, 2013

Such a tribute to the members of Better Homes seemed an appropriate ending to their story. Not only had they succeeded in winning out against prevailing racial discrimination, but they also had created a vigorous and growing community. More than that, they raised a generation of young people who were well educated, productive, professionally successful and civic minded. There can be no greater success than this.

However, such an ending would leave out too much from the past and up to the present. Even while Better Homes was thriving, housing discrimination continued unabated in South Bend. A symposium of the Institute on Minority Housing in 1955, a year after the Better Homes group had celebrated its success, discussed the issue of "open housing." George S. Harris, president of the National Association of Real Estate Brokers, talked about the difficulty for African Americans to find mortgage financing. "The main stumbling block to the free flow of mortgage money to finance minority housing is the 'Gentlemen's Agreement,' an unwritten compact into which bankers, investors, real estate men, and others enter to hamstring schemes for the development of minority housing and for the cessation of segregated housing."[68] Ironically, William Morris, who had organized the symposium, was blackballed for admission into the association of real estate brokers.

At the same time, however, there were a few success stories. In December 1955, after years of failure, Dr. Bernard Vagner's family was at last able to

purchase a home in a sparsely populated white neighborhood on Willow Run in Clay Township just north of South Bend. The house belonged to a Canadian couple who willingly sold it to African Americans. But the Vagners were understandably apprehensive about the reactions of the white neighbors. "We fully expected to come out any time and find a cross on the lawn, but I can truthfully say we have had no trouble whatsoever since we've been there."[69] But much like with Better Homes, there also was little real connection between them and their white neighbors, no more than a wave of the hand as their cars passed on the street.

In 2014, Dr. Vagner provided the full story of how they came to buy the house where he still lives. At ninety-seven years of age, he remains vigorous and witty, with a full head of white hair and sparkling eyes behind his glasses. When they got back from Germany, where he had served for a year and a half, his wife wanted to put an ad in the paper, saying, "Colored physician seeks home near Catholic school." But Dr. Vagner wouldn't have it that way. He was, after all, a physician, plain and simple, not a colored physician. So they changed the ad to say "physician, colored..." They found their house, but after the white owners agreed to sell, the Vagners still needed to procure a loan. This was a tricky business since the house was in an all-white neighborhood. There was, however, one estate agent among many willing to help the Vagners; she already had assisted other African American home seekers. This was the courageous Mrs. Josephine Leahy, a prominent member of the Polish community, who was not afraid to stand up against entrenched racism. Dr. Vagner said that Mrs. Leahy had an estate office, but she was not a realtor, perhaps because she did not want to be part of the realtors' culture. Mrs. Leahy saw the Vagners' ad and contacted them. With her Polish connections, Josephine Leahy got the Vagners a mortgage at Sobiesky Savings and Loan so that their housing trials at last came to a happy conclusion.

Another success in housing desegregation happened three years later in 1958 with a group of South Bend citizens, who called themselves Neighbors United. Josephine Curtis was chair of the Neighbors United Housing Committee. She was a force to be reckoned with, the creator of the H.T. Burleigh Music Association at Hering House with a PhD from the University of Chicago, and one of the most engaged African American citizens in fair housing. Her committee sent out hundreds of letters and made as many telephone calls in order to locate homes for sale or rent in areas where, as the *South Bend Tribune* put it, "Negroes had not believed it possible to acquire residences." The newspaper report about her work carried the headline

An American Story of Courage

This picture is of a meeting of old friends Dr. Bernard Vagner and Leroy Cobb in Dr. Vagner's living room in 2015. Dr. Vagner also was the Cobb's family physician and delivered most of their children. *Photograph by Gabrielle Robinson.*

"Negro Housing Barriers Falling in City." It explained that Neighbors United "has effectively broken down many racial housing barriers in South Bend." While this might overstate the case, Neighbors United did manage to find housing for African American families. The paper added that there had been "very little unhappiness" among whites as a result of this relocation.[70]

Along with Better Homes, the Vagners' experience and the Neighbors United initiative remained isolated successes of the 1950s. There was plenty of evidence that African Americans in South Bend continued to have problems finding houses to buy or rent. Walter Collins wrote in the *South Bend Tribune* that out of 7,569 homes built between 1950 and 1958, no more than 735—and possibly only 400—were for African Americans.[71] The United States Civil Rights Commission reported in 1959: "The area of discrimination in housing in Indiana is probably the greatest blight we are facing in the problems of discrimination affecting the Civil Rights Commission."[72] And in their city-by-city statistical analysis, Taeuber and Taeuber found a very high degree of segregation for South Bend. According

to the measurements they used, in 1960 the percentage of non-whites who would have to move from one block to another in order to achieve integration came to 85.6 out of 100.[73]

The persistence of housing segregation between 1949 and 1963 also was the subject of a public hearing on March 19, 1963. It was organized by two Notre Dame Law professors, Thomas Broden and Conrad Kellenberg, and revealed shocking evidence from African Americans who had been unable to buy or rent a home or purchase a lot in a neighborhood that was not black. Looking back on their initiative, Thomas Broden said: "We wanted to give minority persons a chance to articulate their situation." Both Broden and Kellenberg knew how controversial their hearing was. "We didn't personally attack anyone, but we wanted people to be shocked who hadn't known about this."[74] And it looks as if they achieved this, for Broden's wife, who attended the open hearing, remembers loud booing during testimonies.

Broden knew only too well that one such hearing would not result in immediate change in racial discrimination. "I felt we had to look upon it as a very long-term effort and use every device we could to generate a change in policy and public sentiment." Like many others engaged in the struggle for racial justice, Broden was fully aware that not only policy but also public sentiment had to be changed. Ignorance and indifference still were prevalent among whites when it came to living conditions for African Americans. Forty years after Gordon's book in which he had tried to educate a white public about what was going on in the black community, nothing much had changed. Or as Martin Luther King Jr. said in a sermon: "Nothing in all the world is more dangerous than sincere ignorance and conscientious stupidity."

The hearing showed that it was a matter of race, not class or creditworthiness, that blocked African American home seekers. Helen Arnold's experience in 1957 was a telling illustration of this. Mrs. Arnold held a master's degree and was the wife of a newly hired Notre Dame business professor. She had no trouble locating properties over the telephone, but when realtors saw that the couple was black, homes that had been available over the phone suddenly were no longer for sale or they could not be shown. The Arnolds tried buying, renting and buying land, all to no avail. They could not break through the barrier of segregation and racism.

Particularly striking was the testimony of the distinguished physician Dr. Ronald W. Chamblee, who had served his country from 1941 to 1946, including D-day, and who later was to become president of the Association of General Practitioners of St. Joseph County. After his medical degree from Meharry College, Dr. Chamblee arrived in South Bend as a hospital intern

in 1953, just when Better Homes was in the process of building. In fact, he and his wife were turned down for a house on one of the lower white blocks of North Elmer Street. They tried many realtors and met with the same rejection everywhere. At Whitcomb and Keller, "I got no further than the receptionist, who said they had nothing available. I drove into Cressy and Everett's drive-in parking lot and looked at the beautiful homes on pictures and was told that this was a show and that there were no homes available." When the Chamblees looked around for themselves and found an appealing place on the corner of Twyckenham Avenue and Corby Street, the owner all of a sudden didn't want to sell his house. "We had no one who would show us a home without fear of some reprisal from one of the units in the multiple listing service."[75]

Another testimony came from an unidentified person who did not want to appear or be named for fear of reprisals against his children. It told the story of a family who tried to sell their home on a nondiscriminatory basis in 1960 and engaged African American realtor William Morris. His sign was immediately ripped out of their lawn. This was the beginning of a witch hunt by the neighbors: they threw rubbish at the house late at night, splashed it with paint, uprooted the Chinese elm tree on the front lawn and filed false criminal charges against the couple. Even the family's children did not escape. A female neighbor made it seem as if she was going to run them down with her car; their small daughter was hit on the head by a rock. When the wife got too distressed, the neighbors threatened to submit a request to have her committed to a mental institution. Eventually, the couple withdrew their house from the market and continued to live there.[76]

The year 1963 added another stress factor for the African American community. The Studebaker factory, which had been struggling for a decade, finally shut down. This also hurt members of the Better Homes group. A few, like the Flemings and the Robert Allens, had bailed out early to Chicago once the Studebaker layoffs got more and more frequent. Willie Gillespie had moved to the telephone company and left South Bend altogether after a divorce, and W.C. Bingham had joined the welfare department as soon as it started to hire African Americans. Others, like Orbry Chambers and his wife, did not have Studebaker jobs to begin with and continued their work at the telephone company. After many years as a janitor, Orbry moved up to serviceman. Louis Stanford remained a janitor at the *South Bend Tribune*, and Fred Coker had various jobs with the city. By the time Studebaker shut down, Cobb was well established at the telephone company. He advanced steadily up to better jobs, from mechanic's helper to shop man, followed by

being the first African American in South Bend promoted to craft, which meant framing of wires, a much better job than the previous ones. In 1966, he became a commercial representative for the telephone company, traveling the northwestern part of Indiana. He ended his career in the supply department with top seniority.

But the rest had to scramble for new jobs in a city devastated by the loss of one of its largest employers. In the end, however, everyone from Better Homes secured a permanent job. They were reliable workers, and they managed to survive. A number of them found employment with the post office and several others became school custodians. Gus Watkins also worked for the post office, first as a driver, but he eventually moved up to become director for safety and training for the Motor Vehicles Division. At the end of his career, he founded Watkins Janitorial Services with himself as president. Walter Hubbard worked for a time in the post office but then was retired out for reasons of health. Lureatha's husband, Arnold, briefly was a laborer at the Oliver Corporation but then was hired as a clerk at the post office, which he left only after he suffered a stroke. Both then moved in with their daughter in Florida. Several others became school custodians. Frank Anderson was custodian in a series of schools, first at Marquette Elementary and then at Central High School and Brown and Dickinson Intermediate. After working several construction jobs, Bozzie Williams ended his career as a custodian at Central High School. Bland Jackson started as a porter for Benton's department store but then got a position as custodian at Sinai Synagogue that he kept for thirty years. The rest found various other employments. Sherman Paige was a laborer in the City Street Department until he retired. Clint Taylor had a factory position with Clark Equipment Company that he was able to keep until his retirement. Albert Warfield got a job with Cummings Great Lakes Foundry. Marcus Cecil, already in his eighties, was able to hire on first at Benton's department store and then as an elevator operator at the LaSalle Hotel until the later 1960s, when he finally retired. Fred Coker was a porter, later promoted to custodian, at the courthouse, and then he once again became deputy sheriff, a position he had held back in the 1940s.

So Better Homes members all were able to provide for their families. Moreover they had good places to live in a community they loved. For many other African Americans, Professor Broden's assessment that housing discrimination would not end soon proved all too correct. For years those in favor of segregation and discrimination continued to win out against more liberal and progressive citizens who were trying to get the city to pass a fair

housing ordinance. When Republicans won a majority of seats on the South Bend Common Council in 1964, they managed to bottle up a fair housing proposal in committee. At the same time, the South Bend–Mishawaka Board of Realtors issued a new statement of principles, essentially designed to defend its continued housing discrimination. Although phrased more carefully, it is yet reminiscent of the realtor's code of ethics of the 1940s and 1950s. It declared, "Realtors, individually and collectively…have no right or responsibility to determine the racial, creedal or ethnic composition of any area or neighborhood." A concomitant principle stated that "the property owner whom the realtor represents should have the right to specify in the contract of agency the terms and conditions thereof."[77] When finally the fair housing ordinance was brought to a vote, the *South Bend Tribune* reported, "The controversial fair housing ordinance Monday night died in infancy—killed by unanimous vote of the South Bend Common Council."[78] The unanimous vote was surprising. Similar progressive proposals, as for example the ones in support of public housing, had been defeated by only Republican members of the council. Now that they were in the majority, they must have persuaded Democrat council members to vote with them.

In September 1966, twelve years after the Better Homes celebratory picnic and three years after the hearing Broden and Kellenberg had conducted, a Subcommittee on Citizen's Housing of the Mayor's Committee on Community Development still faced the same issues. Chester Allen and William Morris were members of that committee. After carefully analyzing the factors that affected the housing of minority groups, the committee's first recommendation was "to bring about open occupancy by education and legislation in the South Bend area so that members of the minority group will have free and easy mobility in achieving their housing needs."[79] This group, too, was aware that legislation alone was not enough. For fair and open housing to succeed, the public needed to be educated as well. As Thomas Broden also had recognized, one had to change both policy and public sentiment. So sixteen years after Better Homes was created, fair and open housing was still hotly debated in South Bend and by no means achieved.

If we fast-forward twenty more years, the issues had changed somewhat, but the end result remained the same: it still was more difficult for African Americans to find adequate housing than it was for whites. Working at the South Bend Heritage Foundation in the 1980s, associate director Gladys Muhammad realized that one of the main obstacles for African Americans in buying their own homes was obtaining mortgage loans. She had to get banks first to acknowledge and then to change their conduct concerning loans to

Better Homes of South Bend

African Americans, especially in poorer neighborhoods. Together with her team, she drew a map of South Bend in 1989 that showed dramatically that the entire west side of South Bend, which was largely African American, received less than 1 percent of total loans.

Just like DeHart Hubbard almost forty years before, Gladys Muhammad and her group of representatives from community organizations then went to confront bank presidents, showing them the map. As a result, one bank after another agreed to provide a specified number of loans in targeted areas. These were defined as areas of the city in which 55 percent or more of the population earned less than 80 percent of the median income. Banks had to sign a contract that stipulated the number of loans and the amount they were willing to supply. But that alone was not enough since African Americans, coming from decades of bad experiences, would not easily approach banks on their own. Banks also had to provide credit counseling services and expand credit guidelines designed for these particular clients. They needed to include in their credit assessment wages from second jobs; government assistance, such as food stamps; acceptance of a borrower's own rehab work in lieu of cash down payments; and more. In order to attract a group of now eligible residents, banks also had to initiate a marketing campaign in the targeted areas, including a special brochure that showed African American and not just white clients as in the past.

CA$H PLU$, as the initiative was called, helped many who otherwise would never have applied for or received a loan. Nevertheless, low-income areas, such as the west side of South Bend, continued to be disadvantaged. Poor African Americans still were less likely than others to apply for loans, and when they did, they were turned down at a greater rate than poor whites. There was still some truth to a cartoon Gladys Muhammad had included in her documents in which a well-dressed but worried looking older black couple asks a white banker: "What do we have to do to qualify for a mortgage loan?" The banker's answer is simple: "Turn white."[80]

Loans, though important, were not the only problems facing African American neighborhoods, including the Better Homes blocks on North Elmer Street in the latter part of the twentieth century. A perfect storm was brewing that threatened them from many directions. Even though urban, largely African American poverty dated back decades, the problem was catapulted into even greater prominence with the demolition of South Bend's industry. Where factory buildings once took up many city blocks, there was nothing left but bare lots covered with weeds and dusty grass. For a short time, two local Studebaker dealers used some of the Studebaker buildings

An American Story of Courage

This is how the Studebaker area looks on a map from 2015. Prairie Avenue has no more homes, just parking lots and a few light industrial businesses. *St. Joseph Chamber of Commerce.*

BETTER HOMES OF SOUTH BEND

This picture was taken from Prairie Avenue. It shows the area that once held the foundry and many other Studebaker factory buildings. *Peter Ringenberg, photographer.*

to produce small numbers of hand-built Avanti cars, but that project did not work out for long. Gradually, the mighty plants, around which the workers' homes had been arranged, were taken down. At Oliver Chilled Plow, only the red brick smokestack of the boiler house was left standing as memorial to Oliver's illustrious past. At Studebaker, the Engineering Building and the Foundry complex were not demolished until 2011–12. After that, there were two big holes on the map in the heart of South Bend. Only the six-story body plant still stands today, hollowed out now and with broken windows. In 2015, a group of engaged citizens is working to repurpose the building in what it calls the Studebaker Renaissance. As for the large empty space that once was the Studebaker factory, the city intends to reuse it as a high-technology area called Ignition Park, which it hopes will power the twenty-first century as Studebaker did the twentieth. The administration building on Main Street has been turned into the offices of the South Bend Community School Corporation. The city that grew famous for its Studebaker factory does not want to part with all the vestiges of its former glory.

In addition to the two industrial giants, South Bend's many other major and minor factories shut down as well, eliminating almost all industrial job opportunities. This collapse led to a drastic decline in population and dire poverty among those who remained. The African American population was hit the hardest, especially in the poorer neighborhoods around Lincolnway

An American Story of Courage

Linden School was abandoned in the 1970s and is now taken down altogether. *History Museum of South Bend.*

West and Western Avenue. Their businesses went bankrupt. The Chapin Street business district collapsed entirely, and gradually, so did the one around Birdsell Street. Only the three churches are left standing there in a wilderness of parking lots and empty spaces. Unable to either sell or maintain their homes, many saw no other way than to abandon them. Older people left deteriorated property to their children, who could not find buyers. So the houses stood empty to decline even further. If landlords did buy these properties, they did not maintain them, and they, too, abandoned them when they could not find renters and the houses ceased to be profitable.

Better Homes of South Bend

For its part, the city no longer had the tax revenue to adequately support schools, infrastructure and neighborhoods. For example, La Salle, the only high school in the Better Homes area, was closed, although it still serves as a magnet school for students up to the eighth grade. So, once again as in the 1950s, there is no high school in that neighborhood.

Despite the segregation and racial hatred that prevailed in the 1950s, that era of economic growth and hope for the future was a far cry from the more recent situation. South Bend's population had shrunk from 132,445 in 1960 to 101,168 in 2010, a 23.6 percent decline. This decline was due, in large part, to a lack of jobs. But there was another factor at work as well, for during that same period, city boundaries expanded from 23.9 to 41.6 square miles. Thus, anyone who at all could escaped from the inner city into the suburbs and left the deteriorating center to poor African Americans, who then were blamed for the deplorable conditions in which they had to live. This reinforced segregation and led to a vicious cycle of white prejudice. Or, what is just as destructive, the white population, insulated from city blight, responded with indifference to the plight of African Americans. In *Street Wise*, an ethnographic study of what he calls Village-Northton, Elijah Anderson quotes a policeman who ends his account of unlivable conditions on his beat with this powerful image: "The future is a whirlwind out there. It's a tornado waitin' to happen, and it's gonna tear us apart."[81] In this light, the ending of the Langston Hughes poem of "what happens to a dream deferred?" takes on an even more imminent and ominous meaning. The last line asks: What happens to a dream deferred?

> *Maybe it just sags*
> *like a heavy load.*
> *Or does it explode?*

In order to solve its problems with urban blight before the situation "explodes" or that tornado "tears us apart," South Bend set up a task force in 2012 to initiate a process of city revitalization. The focus was on 1,900 vacant properties, out of which 1,275 were identified as abandoned. Vacant was defined as not having been lived in for at least ninety days, and abandoned was vacant with unpaid code violations.

A good faith effort, the task force has yet met with considerable skepticism from African Americans who live in the area. And indeed, the concluding report contained language that seemed out of touch with the realities on the ground. It said, for example, that "older homes in central

The 2015 map of South Bend shows the empty spaces vacated by South Bend's large industries. *St. Joseph Chamber of Commerce.*

areas sometimes lack modern amenities" whereas "new homes at the edge of the city offer large yards, master suites, and multiple bathrooms." The report mentioned the need for large-scale infill with land banks helping in the redevelopment of entire city blocks. Another recommendation was to "increase financial resources dedicated to demolition" and to "focus on abandoned houses that are a redevelopment site."[82] Such redevelopment would improve the neighborhood, but residents feared that it would also price them out of it. This was Leroy Cobb's take on the task force as well:

"As far as I'm concerned, the city wants too many speculators to come in and develop the area." The skepticism of African Americans about urban renewal is based on long experience. Historically, redevelopment all too often has meant their displacement: "66,000 families were displaced in the nation during the first ten years following the Housing Act of 1949…The future national rate of involuntary displacement is estimated at more than 150,000 families per year."[83]

But then—as Mayor Stephen Luecke explained, based on his sixteen years in office—the city also faces untold challenges in its efforts to improve neighborhoods. It is extremely difficult for the city to obtain abandoned houses and empty lots, even if they pose a hazard. Rightfully so, he noted, since private property has to be respected. But as a result, there are "great limits in how the city is able to intervene" in order to improve a neighborhood. If abandoned houses pose a danger, the city is entitled, even mandated, to tear them down before anyone gets hurt. But it cannot intrude to fix up a property it doesn't own.

The 2012 task force was not the first attempt at city revitalization. There have been two previous projects. In 1956, South Bend had considered participation in the Federal Urban Renewal Program. A Chicago representative of the federal agency came to South Bend and laid out details of the plan to a group of realtors. The plan included the following: "Adequate local codes and ordinances effectively enforced. A comprehensive plan for the development of the community. Analysis of blighted neighborhoods to determine treatment needed. An adequate administrative organization to carry out urban renewal programs. Ability to meet financial requirement. Responsibility for housing families displaced by urban renewal and other governmental activities. Citizen participation."[84] This list could serve as blueprint for all future urban renewal plans in South Bend, including the one of 2012.

The federal program was not implemented in South Bend in 1956. However, in 1960, the city undertook its own redevelopment plan. Strikingly, if you compare the results of the 2012 task force to the 1960 plan, you can find few differences. Only some of the terminology has changed. In 2012, the more positive sounding "infill" has replaced the starker term "clearance." But the issues have not changed since the 1956 federal urban renewal program. In 2012, the city still was trying to come up with a comprehensive plan, one that had to include at once rehabilitation, clearance and rehousing of displaced families. And then it needed to find funds to finance all this. The 2012 task force essentially used the same four categories as the one in

1960, and they applied to the same areas. The first two categories designated stable neighborhoods with either no or only minimal action required. In 2012, neither of these categories was located in African American neighborhoods. And it was the other two categories that posed the problem. The task force defined them as Revitalization and Reinvestment areas. They needed major public investment, with the Reinvestment area slated for total redevelopment. The major change in the map fifty-two years later was that the parts around Lincolnway West and Western marked for major renewal had expanded. In the 1960 plan, the 1700 to 1800 block of North Elmer was in the clear, "little or no action required." But in 2012, the area was in the "Revitalization" section. This meant it needed a number of interventions, from enhanced code enforcement, demolition and land banking to scattered infill development and even some large-scale infill development.

Nevertheless, the two Better Homes blocks of North Elmer Street still stood out. They were considerably better off than the surrounding parts of North Elmer Street and North Olive Street. Houses and yards in the 1700 and 1800 block were well taken care of. There was no trash in the street, and there were only a few empty lots. This still held true in 2015. Therefore, few if any interventions were necessary in the Better Homes stretch. This must be the result of what one might call the enduring "Better Homes effect." A good proportion of the houses in those two blocks still is occupied or owned by the children of Better Homes who take care of them, giving their area a clean, well-maintained face. New people who move into those two blocks follow suit and also take care of their properties.

There was, however, one blight in that neighborhood, and it was 1702 North Elmer Street, the Cobbs' former home. When the Cobbs moved out in 1990 after living there for thirty-seven years, they sold their house to Aaron and Martha Jones, who eventually, when they could not sell it in turn, left it to fall apart. Up to the moment the house was torn down, it had a "For Sale" sign out front. Over the years, neighbors had called the city and code enforcement innumerable times complaining about the condition of the once beautiful house that had become an eyesore as well as a danger to the neighborhood. But nothing was done until the place had deteriorated to such an extent that the city saw no other option than to demolish it entirely. Therefore, in the late summer of 2014, the Cobbs' Elmer Street home was taken down as part of the city's initiative to clear out vacant and abandoned houses. Cobb, who is not given to bitterness or anger, feels angry that the city allowed this to happen. "They neglected that neighborhood completely." He feels certain that if his house had been in an upscale neighborhood, it would

Better Homes of South Bend

An image of 1702 North Elmer just before its demolition shows the deterioration of the once beautiful home. *Courtesy of Beverly Reynolds.*

An American Story of Courage

The empty lot of 1702 North Elmer is in the foreground, followed by the former homes of the Jacksons, Watkins and Thompsons. *Peter Ringenberg, photographer.*

not have been allowed to fall apart like this. The demolition demonstrated that Better Homes, despite all it had achieved, also was part of a continuing story of housing problems for African Americans.

In view of this deterioration, the question arises: how did we get from Better Homes of South Bend to where we are now? This question, as well as the title of this chapter, is taken from Regina Williams Preston's 2013 presentation to the Community Forum for Economic Development. Like all the other participants in this story, Regina, too, has southern roots. Her mother, Thelma, came to South Bend from Covington, Tennessee, in 1961, and her father, George W. Williams, was from Camden, Arkansas. Regina was born in South Bend and, after living and working in many different cities, has chosen to come back to her birthplace to settle only a few blocks from where she grew up. She found, however, that her neighborhood had changed a great deal since her childhood. The once thriving community now was threatened by urban blight. She saw that "the War on Drugs is being waged on our block." This is almost exactly the same phrase Isabel Wilkerson, in *The Warmth of Other Suns*, used to describe the deteriorating neighborhood in Chicago where a former southerner had made her home. Looking down from her apartment at

the once peaceful residential area, "she is an eyewitness to a war playing out on the streets below her."[85]

No doubt remembering the Revitalization and Reinvestment categories of the 2012 task force, Regina Williams Preston said: "They have a plan—a typical neighborhood revitalization plan that doesn't include us." Therefore, "what we need is OUR OWN PLAN to ensure that current residents benefit from the opportunity to invest in their neighborhood. We need a plan to acquire and rehab affordable housing so that current residents can stay in the community they live in, experience the revitalization of the neighborhood around them, and maybe even become an investor in the improvement of their own quality of life." They can do this if they work together, pool their resources and help one another—in a phrase, although she does not say this, if they use "intelligent cooperation."

One step in that direction was the creation of the Far Northwest Neighborhood Association, established in 2013. The group met in the LaSalle Landing Public Housing Community Center. Across from the building is the narrow strip of Fremont Park that had a brightly colored memorial of plastic flowers, toys and a teddy bear at the bottom of an elm tree. At the meeting on Monday, September 15, 2014, about a dozen older people, almost all women, and ten representatives of the Youth and Young Adult Committee sat spread out across the room. Regina Williams Preston, who served as the yet unofficial recording secretary of the organization, was in one of the front rows, her computer ready to go. The meeting started with a prayer, just as all the Better Homes meetings did, but unlike those of Better Homes, this meeting did not have to be secret. One of the older women rose from her chair to ask the Lord to bless the meeting and gave thanks to Him for having protected them that day. Her words were particularly powerful in view of that memorial outside with its bear and flowers.

The young people at the back of the room appeared energized and excited. What had motivated them was the tremendous success of their recent block party, which they had organized under the auspices of the Far Northwest but also as part of their own Fremont Park Youth Foundation. They had wanted it to be a grand affair, and it was. Three hundred children and about two hundred adults, many of them young, came to a party that lasted from ten in the morning to nine at night. There were water slides and bouncing mattresses, basketball games, a kid's dance party and another for the young adults. And of course, there was music. A young man who called himself Yung Blu lit up the crowd—or most of the crowd—with his rap songs. Some of the older members of the association disapproved of his music and his get up,

especially the sagging pants. They also disliked the twerking. Leroy Cobb, the oldest member at the party, was not among them. While also not a fan of the sagging pants, he accepted what these young folk were doing, saying, "Every generation has their own identity; we had the Afros." Instead, he stressed how well run and organized everything was: "Not one bit of trouble did we have." Everyone who attended agreed with that. There was no fighting or even discord, just young people having a good time. The block party showed a lot of community spirit but also the inevitable gap between generations.

 The Fremont Park Youth Foundation also wanted the event to be in memory of a teenager of their neighborhood, a friend and relative to many of them, who had been shot just a few months earlier. Yung Blu told a reporter of the *South Bend Tribune*: "I was in the park when my cousin was killed." His name was Cornell Taylor, and he had lived right across from that memorial in the park. He was only nineteen years old when he died. Cornell "played the drums and the organ at church,"[86] his devastated mother told the newspaper. Because of this love of music, he had joined a group at Fremont Park to watch an amateur rap music video being made. A fight broke out among the crowd, and Cornell was shot by another teenager. The article mentioned that his best friend Jaylin also had been killed.

 Two leaders from the Fremont Park Youth Foundation, Nosha Casey and Kim Clowers, were among the speakers that evening. Kim, a mother of two, lives in LaSalle Landing, and the house of Nosha's mother is across the small strip of Fremont Park that separates the public housing complex from the rest of the neighborhood. The two talked passionately and at rapid-fire speed about all they want to accomplish. They want a splash pond in Fremont Park for the children. Right now the park is just a strip of grass with a shelter and some playground equipment on one end. They also want space in the Community Center. The large building of the South Bend Housing Authority, which once had been the home of Head Start, has a library, computers, movies and other resources, yet the kids of LaSalle Landing public housing aren't allowed to use any of it. The mothers, many of them single, see all this wasted potential that could help make a better life for their children. Nosha enumerated in quick spurts all she and the other young people so desperately want for themselves and their children. They want to keep their friends and children safe and off the streets. But more than that, they want them all to learn, to be able to improve themselves and have a better future. "We're hungry for this, our kids are going to learn and become judges, and lawyers, and doctors." It was a striking phrase, reminiscent of the hunger that runs through Richard Wright's autobiography *Black Boy*, one

part of which he titled "American Hunger." Kim Clowers added: "We're all coming together and standing for something so positive."

One slender young man joined the two women at the front and said quietly: "I grew up here. This is the most beautiful place on earth for me." But it was different when he was a child; there were many activities for kids: a library truck came regularly, there was a Sunday sidewalk school, there were afterschool games and sports. "But suddenly it all disappeared." This young man turned out to be Nosha Casey's brother, Yung Blu. Although still in high school, he has his goal firmly set "to make the world a better place through music."

As the young people talked about Fremont Park, one mother, new to the neighborhood, spoke up: "I have six children, but to be honest, I don't want to send my kids to the park." She doesn't like the groups hanging about gambling and shooting dice or doing nothing at all. Nosha responded that they want to put up a sign declaring their park a "No Gambling Zone." She added that they already have spoken to the children who are gambling, warning them that what they are doing is not only wasting precious time but also dangerous. They might be arrested for gambling or loitering. Many of them, Nosha told us, listened carefully and stopped. "They need to see that other people care for them. It's a new experience."

Such youth leadership as shown by the Fremont Park Youth Foundation constitutes a vital part of any effort at neighborhood regeneration. It helps both the neighborhood and the young people themselves who are engaged in this work. In *Streets of Hope*, an account of the successful Dudley Street revitalization in Boston, the authors stress throughout the crucial role young people have played in re-envisioning and re-creating a vibrant neighborhood out of a desolate and dangerous space. Youth leadership helps the neighborhood association understand the needs of young people, and at the same time, "it encourages youth to better serve their community." If youth are esteemed, "their respect for themselves and their community can grow. It offers young people a chance to develop and exercise leadership skills."[87]

Tim Scott, council representative for the first district, attended the meeting, obviously for the first time. His is the largest South Bend council district. It includes the homes of college professors, lawyers and doctors around Leeper Park and Memorial Hospital, near downtown and along the St. Joseph River. This also is the home of Tim Scott. The area, by the way, was defined by the 2012 task force as needing only minimal public intervention. Scott's district also extends to the Better Homes neighborhood and LaSalle Landing public housing, areas designated by the 2012 task force for revitalization. An older

woman holding a small child in her lap told the councilman with a bit of understandable acerbity: "Nice for once to see the councilman. I am hoping he'll help us to get where we want to go. We helped elect him and he owes us the responsibility to see what's going on in our neighborhood."

Then Rose Wilson, who sat in for the sick president Amanda Carothers, sounded a positive note when she announced that the IRS had granted them their tax exempt status as a public charity under 501(c)(3). Everyone clapped and cheered. They had worked toward this for a year. The price for this achievement, however, was a fee of $400. "We are broke now," Rose Wilson sighed. "So at the next meeting we will have to talk about dues."

It was fitting that Leroy Cobb, now the treasurer of the Far Northwest Neighborhood Association, was at the meeting as the link between then and now. He represented the spirit of courage and "intelligent cooperation" this new group wants to emulate. At the same time, his presence symbolized how the problems of race and poverty persist and repeat themselves, highlighted by the demolition of his Elmer Street home. The demolition was mentioned at the end of the meeting by the code enforcement officer for the area, who comes to many meetings and is supportive of their concerns. In the discussion that followed, Nosha Casey spoke up again, voicing some of the ideas Preston had discussed in her report: "Why did the city not let us rebuild that house and use it rather than tear it down? We need more housing and we could have used local labor to restore it: now all we have is another blight." They all agreed; it made no sense to them. No one was mollified when the councilman mentioned that the city no longer planted grass on empty lots, which grows tall and weedy, but instead used a kind of clover that stays low and looks better.

As the group filed out, a woman came up to Leroy Cobb, telling him quietly: "It was the nicest home on the street." One can barely imagine with what mixture of frustration and hope he attended that day's meeting—frustration that they had to fight their battles over and over again and hope that this group was going to persevere as Better Homes had done and rebuild his neighborhood.

The Far Northwest neighborhood is by no means alone in the problems it faces, either in South Bend or the country as a whole. Locally, the situation in LaSalle Park in the second district may be even worse. The large area between Western Avenue and the park—or Beck's Lake, as old-timers call it—is far removed from the center of town at the western edge of South Bend. LaSalle Park has had a long history of poverty and discrimination. It once was the only place where African Americans could buy land, and it

BETTER HOMES OF SOUTH BEND

This image of St. Adalbert's Via Crucis Procession of 2015 on LaSalle Park hill shows Beck's Lake in the background. *Kay Westhues, photographer.*

has remained almost exclusively African American over the decades. It was fought over in the 1940s when public housing and defense homes came to LaSalle Park. And as recently as 2013, the district has been put on the EPA's National Priorities list for the pollution of its soil.

Nevertheless, there also was a long stretch of time from the 1950s on when LaSalle Park was a well-ordered and thriving community. The rows of defense homes and the tavern and pool hall that flanked them were torn down. In 1961, the city created a park on that site, to which a big hill made out of the rubble was added. That park and that hill are the pride of the neighborhood. African American churches used to hold their Easter sunrise services on top of the hill. They no longer do, but now the Latino community of St. Adalbert's Church organizes a Palm Sunday Via Crucis procession up the hill, complete with three crucifixes. As some of the debris from the defense homes that forms the foundation of the hill shows through the grass, African American residents are determined to find soil to cover it up and make their hill beautiful again. "It's black pride for us," said Gail Brodie, president of the LaSalle Park Neighborhood Association.

Gail Brodie is tall with large dark eyes behind wire-rimmed glasses, her graying hair cut close to her head. Her smile does not hide a certain air of

authority, perhaps acquired on her job at Honeywell as manager of a staff of more than thirty people. She has lived in the same house on Lake Street, a block from the park, since 1951, when she was nine years old. It was the very first house her parents were able to buy, and Gail took it over at age eighteen. She looks back nostalgically to what her neighborhood was like when she was growing up. Her street then was all single family homes, every one of them lovingly taken care of with beautiful, if tiny, front yards. They were good neighbors, looking out for one another and their children. "It was such a nice neighborhood," she sighed with tears in her eyes.

Yet as it is now, Gail Brodie painted a grim picture. Over the years, as the original owners have passed away and their children have moved out, real estate companies have bought the vacated houses for rentals. At first, the renters were responsible single mothers or families, but as the houses deteriorated, these were replaced with an ever more transient group. In addition, they are now surrounded by extensive tracts of public housing in which, Gail Brody estimated, 80 percent of the occupants are engaged in something illegal, from burglary and theft to drugs. In 2014, there are only four single owner homes left on her street. Across Lake Street, as well as farther south toward Western Avenue, it's all either Section 8 rentals or empty, weed-filled lots on both sides of her street. The only exceptions are two well-maintained churches, one of them Latino. Nevertheless, at night, the area is made unsafe with shouting and cursing young people, drunkenness and drugs. Her neighbors are afraid to call the police for fear of retribution. Her next-door neighbor once did, and the police drove to her house before investigating her complaint so that everyone knew who had given the alert. After the police had left, the crowd smashed every window in that neighbor's house. Gail herself is not that easily intimidated, and the few homeowners left call on her help when they are in trouble. Nevertheless, she, too, is afraid and does not feel safe anymore. She no longer goes out by herself at night. Yet she does not want to be driven out of her home either. She wants to remain where she has so much invested, both financially and emotionally. She promised her mother that she would stay in the house, and she is going to keep that promise.

Gail Brodie sees little hope for change. And yet there are a few bright spots for the future of LaSalle Park. The city is going to install fifty-six new streetlights. Moreover, Karen White and Tim Scott of the South Bend City Council, chair and co-chair of the Residential Neighborhoods Committee, are taking up the issues of public health and safety, as well as street and sidewalk improvements, both of crucial importance to LaSalle Park as

well. Perhaps some of this will trickle down to Gail Brodie's neighborhood. "I want to be proud of my community," she said, standing on her porch, covered in spotless outdoor carpeting. She looked out over her small patch of freshly trimmed grass to the chain link fence that surrounds her property. Standing tall, Gail Brodie closely watched a group of young men lounging across the street.

Both the LaSalle Park and the Far Northwest Neighborhood Association simply want what every neighborhood wants: safe streets without trash, run-down properties and drug houses where a constant stream of strangers disturbs the peace. They want their children to be able to attend good schools that prepare them for the future and give them a fair shot at a decent and fulfilling life. In short, they want the values of a middle-class culture, which Elijah Anderson defined this way: "They are concerned with 'good' education for their children, a clean and safe neighborhood, property values, and tolerance toward people who are different from them or deemed less fortunate."[88] "What I really would like," said one woman who has lived in the Far Northwest area for forty years at a neighborhood meeting, "is to come home to a nice neighborhood." This echoes exactly the desires that motivated the Better Homes group. She added: "It's very stressful to me. I don't even want to come home anymore. If I don't feel comfortable in my home, where can I go?"

Charlotte Pfeifer, for twelve years council representative of the second district, which includes LaSalle Park, highlighted some of the issues that have come up in this sketch. Her main point was that for things to change, the neighborhood associations and the individuals living in the area have to take responsibility. They have to raise their concerns again and again, at candidate's hearings, task force meetings and city council meetings. They also need to find a candidate to run for city council who will represent them forcefully and get things done. To be heard, they have to speak with one voice and cannot allow minor or even major differences to separate them as long as they share the same goal of improving their neighborhood. Above all, they have to get organized in order to pursue their mission effectively.

Pfeifer's emphasis on organization to solve the problems that have beset the African American community is not a new idea. In the October 19, 1940 issue of the African American paper the *South Bend Citizen*, which called itself Indiana's fastest-growing weekly, an unnamed contributor made the same point. After deploring that African Americans have not fought back forcefully enough against "almost every type of mistreatment that could be used against human beings," the writer urged the only solution he saw: "All things good and all things powerful point to one thing—THOROUGH

ORGANIZATION."[89] Indeed, it was just this thorough organization and cohesion that helped Better Homes to its success.

Views similar to Charlotte Pfeifer's have been expressed at meetings of the Far Northwest Neighborhood Association, and they invariably won everyone's approval. When one woman spoke up, saying, "We need people who love their community to get into leadership positions," the whole group responded with "Amen." Another woman voiced what she thought was needed first and foremost: "We need to come together to get things done." Again everyone agreed. The members of the Far Northwest Neighborhood Association know that to achieve this, they themselves have to be good neighbors to all around them. In particular, they have to help older people with maintaining their houses and make a concerted effort to include the many renters around them. Merely sending them notices of their meetings is not enough to get people engaged who feel that they have no stake in the neighborhood. Association members have to get to know the renters, talk to them, listen to their concerns and learn their perspective and then include the renters' needs in their agenda. Cherri Peate, director of community outreach for the city, finds that in the neighborhoods, "there are a lot of people who are not talking." Renters and homeowners, Latinos and African Americans, whites and minorities don't talk to one another, and most of them don't communicate with city representatives. Neighborhood associations also have to develop better relationships with police, code enforcement and elected city officials. Many members of these neighborhood organizations are aware of all this, but as Better Homes members have shown, it is a lengthy process that demands both energy and patience.

The 2012 task force was an example of the difficulties in achieving any real connection with the constituencies it was trying to help. One of its major shortcomings was that it didn't manage to create an open communication and did not include those most affected by its decisions. Yet in the introduction to its report, the task force stressed that "the communities most affected by the problem of vacant and abandoned properties must be engaged in shaping and implementing the responses."[90] No doubt, the city wanted to help the neighborhoods, wanted to hear their concerns, but somehow this communication seemed not to work as well as both sides wished, making residents feel abandoned and the city frustrated in its efforts to improve South Bend.

The conclusion to *Streets of Hope* also put much emphasis on communication and inclusion for any effort at revitalization to be successful. It had shown that the Dudley Street rebirth could not have happened without both. At the end

of their account, the authors sum up their findings: "When unaccompanied by large-scale organizing and inclusive action, physical development is a technical process that excludes. It is a disempowering tool. Community development in the truest sense is only possible when the community is organized to control development."[91] In *Collective Courage*, Nembhard likewise considered such an attitude as the best promoter of change: "Many who worry about the survival of our cities recognize that collaboration and cooperation are and will continue to be critical elements in any strategy of community revitalization."[92]

"We need dialogue," Leroy Cobb noted recently, summing it up. An ongoing dialogue will help create an understanding of one another's problems and perspectives that can grow over time if the channels of communication remain open. This will work against what have always been two of the biggest obstacles: ignorance and indifference. As Michelle Alexander noted in her book *The New Jim Crow*: "Racial caste systems do not require racial hostility or overt bigotry to thrive. They need only racial indifference, as Martin Luther King Jr. warned more than forty-five years ago."[93] King also wrote in his "Letter from Birmingham Jail" of April 16, 1963: "We will have to repent in this generation not merely for the vitriolic words and actions of the bad people, but for the appalling silence of the good people."

Dialogue will also help to change public sentiment, which, as has been apparent throughout this account, is of utmost importance. To improve race relations and create social justice, public sentiment needs to be changed as much as legislation. This is what Michelle Alexander emphasized as well. In demonstrating how "the American penal system has emerged as a system of social control unparalleled in world history,"[94] she, too, sees no reformation possible without changing the public sentiment that helped to create that system. "Unless the public consensus supporting the current system is completely overturned, the basic structure of the new caste system will remain intact."[95] If dialogue can help change minds and hearts and if neighborhood associations can maintain confidence in their vision, speak up as well as listen to others' perspectives and be as inclusive as possible, they may well succeed just like the Better Homes group did many years ago.

Thus the lessons from Better Homes remain useful today. First of all, the group acted only after having prepared itself thoroughly. Even before it officially got started, its members had organized a clear leadership structure to which they stuck throughout. Aware of powerful opposition, they decided on the utmost secrecy in all their initial preparations and became public

only after they were already firmly established. At the same time, they were committed to hearing everyone's concerns and suggestions and following a strictly democratic process. They discussed every step, allowed all questions to be aired and then took a vote before every major action.

Next and after much consideration, Better Homes made strategic choices that served its members well. One was cooperative building, which helped in so many ways: it gave them stronger representation, and it aided in placing the land options and getting the initial loan in the name of the corporation. Another was the choice of location for their homes. The land they bought was at the edge of South Bend, where there were a large number of empty lots. It was undeveloped and sparsely populated by a handful of white families. Yet right up to the 1700 block of North Elmer, there were a larger number of white working-class home owners who might have reacted as ferociously as, for example, the people in Cicero, Illinois, did at about the same time. Perhaps they were lucky in this, but then South Bend did not suffer the violence that shook Chicago and made Martin Luther King say, in 1966 during the marches of the Chicago Freedom Movement, "I have never seen such hostility and hatred anywhere in my life, even in Selma."[96] Nevertheless, as the Broden and Kellenberg hearing had demonstrated, there also were persistent and violent reactions in South Bend to African Americans coming into white neighborhoods. That this didn't happen with Better Homes may indicate that it had some luck on its side after all.

Better Homes members also had a good understanding of the limits of their capabilities. In particular, the corporation was aware that that it needed expert legal support. Therefore, it secured the help of Attorney Chester Allen while it was planning its strategies. He was a perfect ally for the group, a respected political leader of South Bend who had been a member of the state legislature and a man with an unrelenting commitment to racial justice. Allen's influence was decisive throughout, and the group followed his advice in all major matters.

In his turn, Allen knew when he himself needed outside help. He connected with other lawyers; he wrote to city officials and organized meetings with them. And perhaps most importantly, Allen called in DeHart Hubbard, race relations advisor from the FHA. Hubbard was another decisive factor in Better Homes' success, especially when it came to securing mortgages. With the power of the FHA behind him, he confronted bank executives who otherwise were unwilling to grant loans to African Americans.

When all its efforts seemed to grind to a halt, Better Homes had another bit of serendipity in that Nathan Levy happened to be in Ann Arbor and

met there with Nola Allen. Serendipity plays a part in any success, but it works only when the groundwork has been prepared for it with organization and hard work. It was Levy's behind-the-scenes action and Allen's willing cooperation that triggered the group's final success.

Most of the credit for the achievement of Better Homes goes to its courageous and insightful leadership and the staunch support of all its members. They reached out to everyone who might affect their future. They not only collaborated among one another but also established relationships and networks with anyone who might help them. They met with city officials and listened to their views. They consulted with local banks. They made numerous trips to the Indianapolis FHA to get advice. It was a long process of listening, learning and hard work sustained over many years. Then when it came to take action, they made their decisions democratically and followed them courageously. Above all, they were patient and persevered despite years of delays and setbacks. They were not afraid to stick to their vision and pursue it, united together, speaking with one voice. Better Homes earned its success through courage and "intelligent cooperation."

Notes

Chapter 1

1. *South Bend Tribune*, "Better Homes Institute in South Bend," October 11, 1944.
2. Du Bois in Nembhard, *Collective Courage*, 189.

Chapter 2

3. Details about the Allens and the defense homes provided by their daughter, Nola Allen.
4. O'Dell, *Our Day*, 71.
5. Long and Hansen in Wilkerson, *Warmth of Other Suns*, 264.
6. Irving Allen, typed biography of Elizabeth Allen in J. Chester Allen and Elizabeth Fletcher Allen Papers.
7. Talladega College quotations from college's website.

Chapter 3

8. Gordon, *Negro in South Bend*, 56.
9. Thornbrough, *Indiana Blacks*, 35.
10. Grossman, *Land of Hope*, 5.

11. Helen Pope, oral history, Helen Pope Papers, Civil Rights Heritage Center.
12. Leroy Cobb, interview with the author, 2014.
13. Gordon, *Negro in South Bend*, 68.
14. Ibid., 49.
15. Ibid., 53.
16. Ku Klux Klan details from African American Landmark Tour.
17. Statistics on factories, Gordon, *Negro in South Bend*, 78.
18. Thornbrough, *Indiana Blacks*, 42.
19. Helen Pope Papers.
20. O'Dell, *Our Day*, 21–22.
21. Hank's Pool Hall details, Civil Rights Heritage Center website.
22. Haygood, *Pilgrim Missionary Baptist Church*, 37.
23. Gordon, *Negro in South Bend*, 67.
24. Swedarsky, *Place with Purpose*, 76.
25. Pope papers, Civil Rights Heritage Center.
26. Anderson, *Street Wise*, 241.

Chapter 4

27. Patrick Furlong, emeritus professor of history Indiana University South Bend.
28. Allen, "Story of House Bill No. 445."
29. *The Elite*, January 21, 1944, 4.
30. Abrams, *Forbidden Neighbors*, 156.
31. Ibid., 230.
32. *South Bend Tribune*, April 8, 1945.
33. Ibid., February 4, 1945.
34. Ibid., July 28, 1938.
35. Ibid., March 3, 1942.
36. Ibid., October 26, 1943.
37. Ibid., February 20, 1942.
38. Ibid., December 11, 1943.
39. O'Dell, *Our Day*, 58.
40. Du Bois, *Souls of Black Folk*, 146.
41. Ibid., 8–9.
42. Chas. A. Wills, "Sold Down the River," *The Elite*, March 17, 1944, 1.
43. *South Bend Tribune*, October 25, 1943.
44. Ibid., October 27, 1943

45. Abrams, *Forbidden Neighbors*, 186.
46. Thornbrough, *Indiana Blacks*, 106.
47. Meyer, *As Long as They Don't Move Next Door*, 221.
48. Halberstam, *Fifties*, 141.
49. Mrs. Vagner's testimony, "Public Hearing on Discrimination," 31–32.
50. Healy, "William R. Morris."
51. *South Bend Tribune*, September 10, 1950.
52. Meyer, *As Long as They Don't Move Next Door*, 118.
53. Ibid., 119.
54. Hansberry, *Raisin in the Sun*, 118.
55. Ibid., 119.
56. Nemiroff and Hansberry, *To Be Young, Gifted and Black*, 20–21.

Chapter 5

57. Abrams, *Forbidden Neighbors*, 211.
58. Nembhard, *Collective Courage*, 29.

Chapter 6

59. *South Bend Tribune*, February 21, 1972.

Chapter 7

60. Ibid., June 22, 1951.
61. Gary Gilot, environmental engineer and recently retired director of Public Works for the city of South Bend.
62. After the October 26 general meeting, the minutes have been copied differently. Now, there are two pages on each sheet, and the date of several meetings is cut off. It can, however, be surmised from the context.
63. Gary Gilot.
64. *South Bend Tribune*, June 22, 1951.

Chapter 8

65. Ibid., July 2, 1974.
66. Ibid., July 26, 1998.
67. Stacey, *Black Home Ownership*, 82-83.

Chapter 10

68. Subcommittee on Citizen's Housing.
69. "Public Hearing on Discrimination," 34.
70. *South Bend Tribune*, February 10, 1959.
71. Ibid., November 13, 1958.
72. Thornbrough, *Indiana Blacks*, 182.
73. Taeuber and Taeuber, *Negroes in Cities*, 33.
74. Thomas Broden, interview with the author, 2015.
75. "Public Hearing on Discrimination," 24.
76. Ibid., 38–39.
77. *South Bend Tribune*, February 15, 1964.
78. Ibid., February 25, 1965.
79. Subcommittee on Citizen's Housing.
80. CA$H PLU$ details from Gladys Muhammad, associate director of South Bend Heritage Foundation.
81. Anderson, *Street Wise*, 246.
82. Vacant and Abandoned Properties Task Force Report, February 2013, 10.
83. Stacey, *Black Home Ownership*, 10.
84. *South Bend Tribune*, November 2, 1956.
85. Wilkerson, *Warmth of Other Suns*, 467.
86. Madeleine Buckley, *South Bend Tribune*, March 23, 2014.
87. Medoff and Sklar, *Streets of Hope*, 259.
88. Anderson, *Street Wise*, 237.
89. *South Bend Citizen*, J. Chester Allen and Elizabeth Fletcher Allen Papers.
90. Vacant and Abandoned Properties Task Force, February 2013, 10.
91. Medoff and Sklar, *Streets of Hope*, 260.
92. Nembhard, *Collective Courage*, 13.
93. Alexander, *New Jim Crow*, 14.
94. Ibid., 8.
95. Ibid., 18.
96. Meyer, *As Long as They Don't Move Next Door*, 186.

Selected Bibliography

Abrams, Charles. *Forbidden Neighbors: A Study of Prejudice in Housing*. New York: Harper and Brothers, 1955.

African American Landmark Tour. Civil Rights Heritage Center website. Indiana University South Bend.

Alexander, Michelle. *The New Jim Crow: Mass Incarceration in the Age of Colorblindness*. New York: New Press, 2010.

Allen, J. Chester. *The Indiana Plan of Bi-Racial Cooperation*. Pamphlet 3. Indianapolis: Indiana State Defense Council, April 1942.

———. "The Story of House Bill No. 445…A Bill that Failed to Pass and the Problem of the Negro in Industry…A Question That Lives On." Indianapolis: Indiana State Chamber of Commerce, 1941.

Anderson, Elijah. *The Cosmopolitan Canopy: Race and Civility in Everyday Life*. New York: W.W. Norton, 2011.

———. *Street Wise: Race, Class, and Change in an Urban Community*. Chicago: University of Chicago Press, 1990.

Du Bois, W.E.B. *The Souls of Black Folk*. New York: Vintage Books, 1990.

Gordon, Buford F. *The Negro in South Bend: A Social Study*. Edited by David H. Healey. South Bend, IN: Wolfson Press, 2009.

Grossman, James R. *Land of Hope: Chicago, Black Southerners, and the Great Migration*. Chicago: University of Chicago Press, 1989.

Halberstam, David. *The Fifties*. New York: Villard Books, 1993.

Hansberry, Lorraine. *A Raisin in the Sun*. New York: Vintage, 2004.

Selected Bibliography

Hawley, Amos H., and Vincent P. Rock, eds. *Segregation in Residential Areas: Papers on Racial and Socioeconomic Factors in Choice of Housing*. Washington, D.C.: National Academy of Sciences, 1973.

Haygood, Reverend H. Gregory. *Pilgrim Missionary Baptist Church 1890–1990*. N.p., 1990.

Healey, David. "William R. Morris Advocate for Social Change." Collections of Civil Rights Heritage Center, Indiana University South Bend Archives, February 9, 2004.

Helen Pope Papers. Collections of Civil Rights Heritage Center. Indiana University South Bend.

J. Chester Allen and Elizabeth Fletcher Allen Collection. Collections of Civil Rights Heritage Center, Indiana University South Bend Archives.

J. Chester Allen and Elizabeth Fletcher Allen Papers. History Museum Archives, South Bend, Indiana.

Johnson, Philip A. *Call Me Neighbor, Call Me Friend: A Case History of the Integration of a Neighborhood on Chicago's South Side*. Garden City, NY: Doubleday, 1965.

Lieberson, Stanley. *A Piece of the Pie: Blacks and White Immigrants Since 1880*. Berkeley: University of California Press, 1980.

Long, Herman H., and Charles S. Johnson. *People vs. Property: Race Restrictive Covenants in Housing*. Nashville, TN: Fisk University Press, 1947.

Medoff, Peter, and Holly Sklar. *Streets of Hope: The Fall and Rise of an Urban Neighborhood*. Boston: South End Press, 1994.

Meyer, Stephen Grant. *As Long as They Don't Move Next Door: Segregation and Racial Conflict in American Neighborhoods*. Lanham, MD: Rowman and Littlefield, 2000.

Nembhard, Jessica Gordon. *Collective Courage: A History of African American Cooperative Economic Thought and Practice*. University Park, PA: Penn State University Press, 2014.

Nemiroff, Robert, and Lorraine Hansberry. *To Be Young, Gifted and Black: Lorraine Hansberry In Her Own Words*. Englewood Cliffs, NJ: Prentice Hall, 1969.

O'Dell, Katherine. *Our Day: Race Relations and Public Accommodations in South Bend, Indiana*. South Bend, IN: Wolfson Press, 2010.

"Public Hearing on Discrimination in the Sale, Rental, and Financing of Private Housing in South Bend and Mishawaka," March 19, 1963. Local & Family History. St. Joseph County Public Library.

Schussheim, Morton J. "Housing in Perspective." *Public Interest*, Spring 1970: 18–43.

Stacey, William A. *Black Home Ownership: A Sociological Case Study of Metropolitan Jacksonville*. New York: Praeger, 1971.

Selected Bibliography

Subcommittee on Citizen's Housing. Local & Family History. St. Joseph County Public Library.

Swedarsky, Lisa. *A Place with Purpose: Hering House 1925–1963*. South Bend, IN: Wolfson Press, 2009.

Taeuber, Karl E., and Alma F. Taeuber. *Negroes in Cities: Residential Segregation and Neighborhood Change*. Chicago: Aldine Publishing Company, 1965.

Thornbrough, Emma Lou. *Indiana Blacks in the Twentieth Century*. Bloomington: Indiana University Press, 2000.

Vacant and Abandoned Properties Task Force Report, February 2013.

Wilkerson, Isabel. *The Warmth of Other Suns: The Epic Story of America's Great Migration*. New York: Random House, 2010.

Wright, Gwendolyn. *Building the Dream: A Social History of Housing in America*. Boston: MIT Press, 1983.

Wright, Richard. *Black Boy (American Hunger): A Record of Childhood and Youth*. New York: Perennial Classics, 1998. The restored text established by the Library of Congress.

Index

A

Alexander, Michelle 130
Allen, Arnold 19, 20, 35, 58, 67, 76, 79, 100
Allen, Dr. Irving 8, 24, 26
Allen, Elizabeth 26, 57, 91, 133
Allen, J. Chester 8, 11, 14, 19, 23, 24, 25, 34, 43, 45, 46, 47, 55, 58, 59, 65, 66, 67, 68, 69, 71, 72, 74, 75, 77, 78, 79, 80, 84, 86, 87, 90, 91, 111, 131, 132, 133, 136, 138
Allen, Lureatha 7, 11, 13, 19, 20, 21, 55, 58, 59, 67, 78, 83, 85, 87, 88, 91
Allen, Nola 7, 8, 11, 20, 71, 74, 85, 100, 132, 133
Anderson, Edgar 69
Anderson, Elijah 41, 116, 128
Anderson, Frank 8, 76, 97, 103, 110
Arnold, Helen 108

B

Beck's Lake 46, 47, 125, 126
Bendix Company 31
Bingham, Kathy 8, 59, 95, 101, 103
Bingham, Keith 8, 99, 101
Bingham, William 59, 60, 61, 67, 76, 87, 109
Blake, Hartie 14
Board of Realtors 50, 51, 111
Braboy, Eugenia 60
Broden, Thomas 8, 108, 110, 111
Brodie, Gail 8, 126, 127, 128

C

CA$H PLU$ 112
Carothers, Amanda 8, 125
Casey, Nosha 123, 124, 125
Cecil, Marcus 59, 60, 66, 75, 78, 110
Central High School 38, 50, 61, 98, 99, 100, 110
Chambers, Orbry 76, 77, 88, 102, 109
Chambers, Ruth 59, 79, 101
Chamblee, Dr. Ronald 57, 108
Cicero, Illinois riots 52, 131
Clowers, Kim 123
Cobb, Beverly Reynolds 8, 103
Cobb, Jim 46
Cobb, Leroy 7, 8, 19, 26, 27, 33, 38, 39, 61, 62, 64, 65, 67, 69, 71, 72, 74, 75, 77, 79, 83, 84, 85,

INDEX

86, 87, 88, 90, 91, 94, 98, 102, 103, 104, 109, 117, 119, 123, 125, 130
Cobb, Leroy, Jr. 98
Cobb, Margaret 61, 101
Cobb, Mary 46
Cobb, Vicki Belcher 8
Coker, Fred 35, 67, 74, 76, 77, 78, 96, 109, 110
Colfax Theater 31
Curtis, Josephine 38, 106

D

Davison, Reverend F.E. 43, 47, 48
defense homes 16, 21, 33, 44, 46, 47, 87, 126, 133
Du Bois, W.E.B. 17, 30, 47, 133, 134, 137

E

Elite, The 44, 134
Engman Natatorium 25, 26, 34

F

Fagan, Vincent F. 80
fair housing
 citizens' housing committee 1937 45
 Neighbors United Housing Committee 1958 106
 public hearing concerning discrimination, 1963 108
 Subcommittee on Citizen's Housing 111, 136, 139
 symposium of the Institute on Minority Housing 105
Far Northwest Neighborhood Association 8, 122, 125, 128, 129
Federal Housing Authority (FHA) 44, 58, 67, 68, 73, 77, 78, 80, 81, 84, 85, 90, 131, 132
First African Methodist Episcopal Zion Church 30
Frazier, Reverend John T. 38, 62, 90
Fremont Park Youth Foundation 122, 123, 124

Fuller, Beautha 59, 61
Fuller, Wade 61, 75, 84, 103

G

Gillespie, Willie 64, 76, 109
Gilot, Gary 9
Gordon, Buford 27, 30, 31, 36, 38, 48, 108
Great Migration 27, 137, 139

H

Hank's Pool Hall 34, 134
Hansberry, Lorraine 52, 53
Hering House 16, 33, 34, 38, 39, 40, 41, 47, 62, 66, 72, 73, 106, 139
Highland Cemetery 57
Hubbard, DeHart 58, 67, 68, 72, 73, 74, 75, 79, 80, 83, 84, 85, 87, 90, 112, 131
Hughes, Langston 53, 116

I

Institute on Minority Housing 105

J

Jackson, Bland 13, 23, 59, 66, 75, 86, 87, 88, 103, 110
Jackson, Michael 8, 93, 94, 95, 97, 98, 101

K

King, Martin Luther, Jr. 108, 130, 131
Ku Klux Klan 30, 134

L

LaSalle Park 8, 9, 46, 47, 72, 125, 126, 127, 128
La Salle, Robert Cavelier de 46, 57, 116
Leahy, Josephine 106
Levittown 49
Levy, Nathan 7, 85, 86, 131, 132
Linden School 28, 29, 30, 34, 104, 115
Luecke, Stephen 9, 118
Luton, Joe 27, 104

Index

M

Maggie's Court 33, 41, 45, 46, 48, 62
Ma Hodges Hotel and Restaurant 33
Meyer, Max 73, 75, 78, 80, 84, 85
Meyer, Stephen Grant 49
Milan, William 73
Morris, William 50, 51, 105, 109, 111
Muhammad, Gladys 8, 99, 111, 112, 136
Myers, Edward 104

N

NAACP South Bend Chapter 24, 35, 51
Nembhard, Jessica Gordon 59, 130, 133, 135, 136, 138
North Elmer Street 8, 9, 55, 57, 64, 65, 68, 69, 71, 75, 76, 86, 88, 89, 96, 99, 101, 103, 109, 112, 119

O

Oldham, Algie 104
Oliver Chilled Plow Company 24, 28, 31, 33, 48, 110, 114
Olivet African Methodist Episcopal Church 21, 30, 34
Our Day Together Club 38, 59

P

Paige, Ruby 13, 22, 58, 59
Paige, Sherman 22, 23, 59, 61, 76, 110
Pfeifer, Charlotte 8, 41, 128, 129
Pierian Club 21
Pilgrim Missionary Baptist Church 34, 35, 36, 48, 134, 138
Pope, Helen 28, 31, 41
Preston, Regina Williams 8, 105, 121, 122, 125

R

Roosevelt, President Franklin D. 49, 61

S

Sands, George 69, 78
Sanhedrin Club 34
Singer Sewing Machine Company 31
South Bend Citizen 128
South Bend Tribune 45, 46, 48, 51, 80, 87, 106, 107, 109, 111, 123
Stanford, Louis 76, 77, 78, 88, 100, 103, 109
St. Augustine's Catholic Church 34, 36
St. John Missionary Baptist Church 21, 23, 34, 36, 37, 40, 46
St. Pierre Ruffin Club 59
Streets, Dr. B.W. 31, 51
Streets of Hope 124, 129, 136, 138
Studebaker Company 114
 foundry 9, 13, 14, 16, 23, 61, 62, 63, 102, 114
 Ignition Park 114
 Studebaker Renaissance 114

T

Talladega College 24, 26, 133
Taylor, Cleo 59, 79, 87, 88
Taylor, Louise 13, 59, 61, 79
Thompson, Earl 13, 21, 23, 28, 75, 87, 88
Trianon Dance Hall 33

U

Uncle Bill's Big House 34, 40
urban renewal
 Federal Urban Renewal Program 1956 118
 South Bend Redevelopment Plan 1960 118
 Vacant Abandoned Properties Task Force 2012 116, 117, 118, 119, 122, 124, 128, 129

W

Wright, Richard 123

Y

Yung Blu 122, 123, 124

About the Author

Gabrielle Robinson was born in Berlin at the end of World War II. She has lived in many different cities from Hamburg, Germany, to Vienna, London and New York. But she has happily settled down in South Bend, Indiana, with her husband, Mike, and their cat, Max. She has been awarded the keys of the city of South Bend and a Sagamore of the Wabash, Indiana's highest honor.

Gabrielle received her PhD from the University of London in modern drama. She has worked at universities in the United States and in Europe and is now a professor emerita of English.

After writing academic books, Gabrielle turned to local history and most recently to German history with her memoir/biography about her grandfather in Berlin in 1945. Her current book, *Better Homes of South Bend: An American Story of Courage*, is a contribution to a part of history that all too often is forgotten both locally and nationally. Find her online at Gabriellerobinson.net.

Gabrielle Robinson, 2015. *Peter Ringenberg, photographer.*